C000177237

HARWICH &
DOVERCOURT
THROUGH TIME
Michael Rouse

AMBERLEY PUBLISHING

For the local historians, like the late Phil Cowley, for the Harwich Society and for the residents' associations, and all those who love, value and keep alive the heritage around them for all to appreciate and enjoy.

First published 2013

Amberley Publishing
The Hill, Stroud, Gloucestershire, GL5 4EP
www.amberley-books.com

Copyright © Michael Rouse, 2013

The right of Michael Rouse to be identified as the
Author of this work has been asserted in accordance with
the Copyrights, Designs and Patents Act 1988.

ISBN 978 1 4456 2309 2 (print)
ISBN 978 1 4456 2314 6 (ebook)

All rights reserved. No part of this book may be reprinted
or reproduced or utilised in any form or by any electronic,
mechanical or other means, now known or hereafter
invented, including photocopying and recording, or in
any information storage or retrieval system, without the
permission in writing from the Publishers.

British Library Cataloguing in Publication Data.
A catalogue record for this book is available from the
British Library.

Typesetting by Amberley Publishing.
Printed in Great Britain.

Introduction

Daniel Defoe, in his *Tour Through the Whole Island of Great Britain*, published in 1724, described Harwich as '...a town of hurry and business, not much of gaiety and pleasure; yet the inhabitants seem warm in their nests, and some of them are very wealthy'. The business of Harwich, at the mouth of the River Orwell, was ships and shipping.

For many people, the coast was a dangerous area, often overwhelmed by the sea. It was inhabited by tough, seafaring folk, fishermen and sailors. The East Anglian coast, battered by the German Ocean, was often under threat of attack and invasion. Much of the coast was marshy and low-lying, damp and misty, and therefore deemed unhealthy. All in all, there were few attractions to living by the sea or visiting there.

In the 1750s, Sir John Floyer proclaimed the benefits of seawater for both bathing and drinking to cure many common ailments, as did Dr Richard Russell at Brighton, which led to that town developing as a coastal spa. When in 1783 the Prince of Wales, later to become King George IV, visited Brighton and then built a house there, its reputation was established as the centre of Regency fashion. Soon those who could afford it were taking the seawater cure, drinking it and being dipped in it. What a brilliant business plan, exploiting something that was all around the island in endless supply and free!

As early as 1753, Mr Hallsted of the Three Cups in Church Street, Harwich, was inviting people to stay at his inn and take the seawater cure at his new baths. In 1854, the brewer Thomas Cobbold opened a rival set of baths, and by 1760 he was running the only one. *The Harwich Guide* of 1808 gives a good description:

> the private baths are very neat and convenient. These stand in a large reservoir of seawater, which is changed every tide ... in two of the baths the seawater is made hot for the use of invalids; who, if they have neither strength nor courage to plunge themselves into the water, are assisted with a chair. Here are also vapour baths, and a partial large bathing place, with a machine to throw the seawater, either hot or cold, on any part of the body.

Soon other seaside places were developing as health resorts. Victorian engineers and entrepreneurs like Samuel Morton Peto and Peter Schuyler Bruff were active in East Anglia in Victorian times, especially when the railways gave greater access from the towns. John Bagshaw (1784–1861), former East India merchant and Whig politician, was elected as MP for Harwich in 1847. He had taken over the shipyard there and built himself a large mansion, Cliff House, with extensive grounds overlooking Dovercourt Bay. John Bagshaw had ambitious plans to develop a fashionable new seaside resort at Dovercourt.

Harwich remains a small town with a rich naval heritage, including links to Christopher Jones, the Master of the *Mayflower*, and work is currently going on to create a working replica of the Pilgrim fathers' ship to further establish Harwich as a maritime centre. Samuel Pepys, who was appointed secretary to the Admiralty in 1673, and was Master of Trinity House in

1676/77 and 1685/86, was also MP for the town in 1679 and from 1685–87. It is a town with many small public houses and good restaurants and always something to see from the quayside and the Ha'penny Pier.

There is a bracing walk and cycle way from Harwich along the coast around Beacon Hill to Dovercourt. Turning the sharp bend from which the long stone breakwater projects into the sea, it is possible to see the whole sweep of the bay and where John Bagshaw's dream began and ended.

Anyone who reads my books on the East Anglian coast will know that I love the seaside, whether it be crowded with people or enjoyed by a few walkers, joggers and cyclists. I love dodging the waves crashing onto the promenade, strolling along the sea-swept sand or just watching the ships gliding past. The seaside is our greatest Natural Health Service, and this is a book about holidaying by the sea where Harwich and Dovercourt on the Essex coast are a tonic.

Michael Rouse
Ely, September 2013

Acknowledgements

Some of the information is taken from my original research for *Coastal Resorts of East Anglia, The Early Days*, published by Terence Dalton in 1982. The books of Phil Cowley, *Harwich and Dovercourt in Old Picture Postcards, Vol. 1* (European Library, 1993, reprinted 2011), *Harwich Dovercourt and Parkeston, Vol. 2* (SB Publications, 2001) and *Harwich, Dovercourt and Parkeston, Vol. 3* (John Nickalls, 2004) have been an invaluable source of information, as has Leonard Weaver's *The Harwich Story*, published in 1975. I have also consulted *Harwich and Dovercourt* by John Mowle (Tempus, 2001 and 2003), and several old guides. I recommend the website 'Harwich & Dovercourt, a Time Gone By' as a fascinating source of historical information.

Special thanks to the Parker family, not only for launching their boats into choppy waters, but even more importantly for finding the credit cards I dropped while taking my photographs; Dr Kate Felus of Historic Landscapes for answering my query on the stone landscaping of the Cliff Gardens; The Harwich and Dovercourt Roller Skating Rink, and my two skaters; the Cliff Hotel; the Dovercourt Caravan Park; the Blue Flag Café, especially the extra beans; the Harwich Society and anyone who answered my queries or pointed me in the right direction.

My photographs were taken on three visits: 29 August, when my younger son, Lee, was both company and a model, 7 September and 28 September 2013.

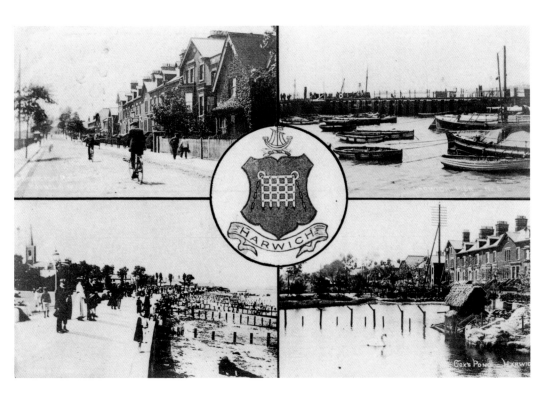

Harwich, *c.* 1910

Written to Stretham, London, on 9 August 1910: 'You will see we are at the old spot once more, we come back next Saturday. We have had a lovely time ... love to you all, Percy and Hattie.'

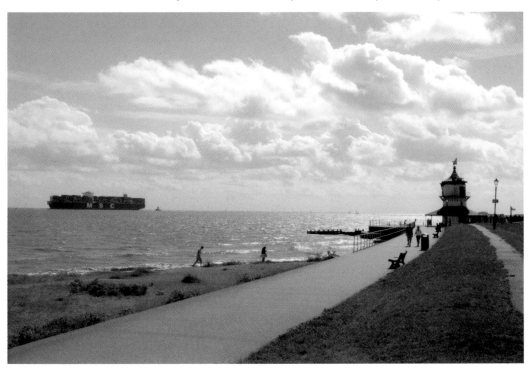

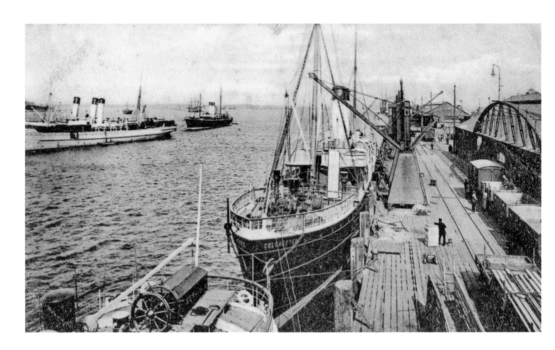

Parkeston Quay, *c.* 1906

'Was over here in the yatch [*sic*] with my friends. Mater is going on nicely. Tell uncle I will write to him and send him that book.' Parkeston Quay was developed by the Great Eastern Railway (GER) between 1879 and 1883, on the southern side of the River Stour upstream of Harwich, to cater for the larger ships, as there was no more capacity at Harwich. It became the most important port linking England with Belgium and Holland. Since 1997, it has been owned by Hutchinson Ports (UK) Ltd.

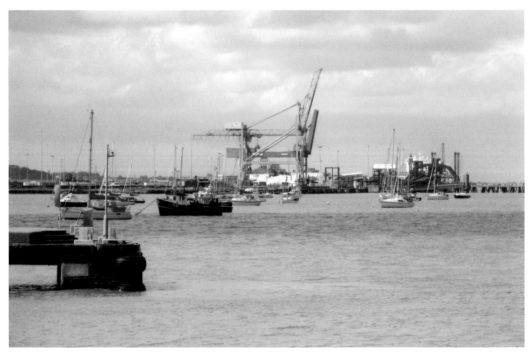

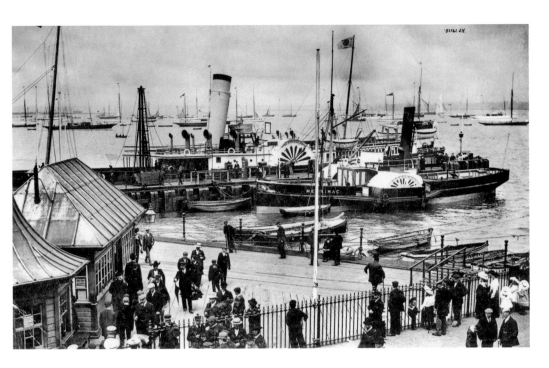

Pier and Harbour, Harwich, *c.* 1918
Written to Garstang in Lancashire, July 1918: 'I am getting used to my new life now. We are under canvas and having good weather. Jack and I went to Harwich last night, it is not so much of a place ... they train you for fourteen weeks here and then you are ready...' A reminder that Harwich and Dovercourt were closed to holidaymakers between 1914 and 1918 during the years of the First World War, but both were full of soldiers and sailors. Below, the Felixstowe Ferry.

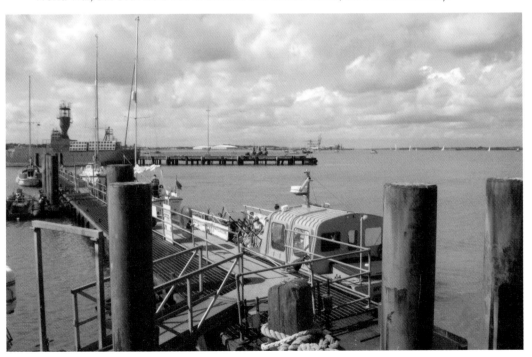

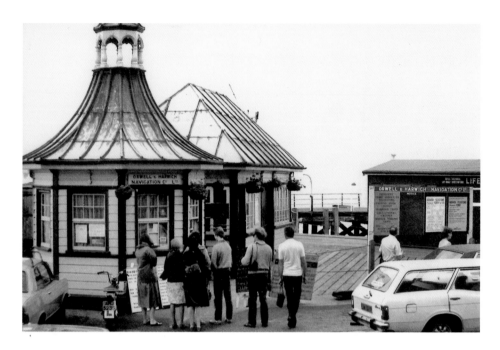

Ha'penny Pier, c. 1980

In 1854, the year the railway arrived in Harwich, the Ha'penny Pier was built as the ticket office for the Continental ferries and the local paddle steamers. There was a waiting room for passengers. In 1865, Maud Homer, of whom more later, went to Harwich and took a river trip on the *Stour* along the Orwell to Ipswich. The river they found 'a little disappointing', but Ipswich was 'clean' and 'well shopped'. Today there is a very helpful visitor centre and busy café. It is an ideal spot for watching all the activity and catching the ferry across to Felixstowe.

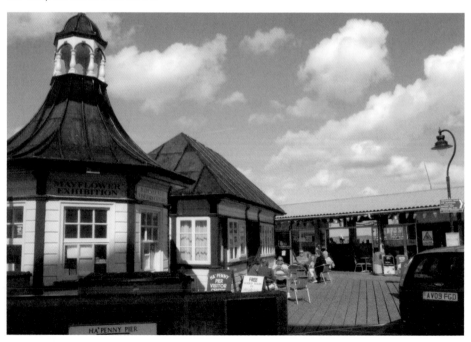

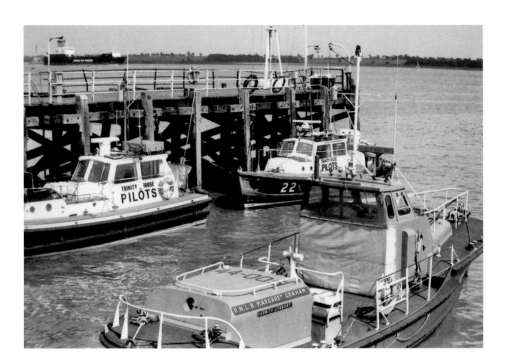

Trinity House Pilots and Lifeboat, *c.* 1980

The Lightship LV18, which was the last manned lightship in the UK, is now permanently moored here as a museum ship. These are busy waters and the RNLI has two lifeboats stationed at Harwich: an inshore lifeboat kept next the RNLI shop on the quay and an offshore lifeboat on the waterfront. The *Margaret Graham* was a Waveney class lifeboat built by Brooke Marine at Lowestoft, and came into service in 1967. In 1980, she became the relief lifeboat until 1986, before going to Amble and then becoming a pilot boat at Whitby.

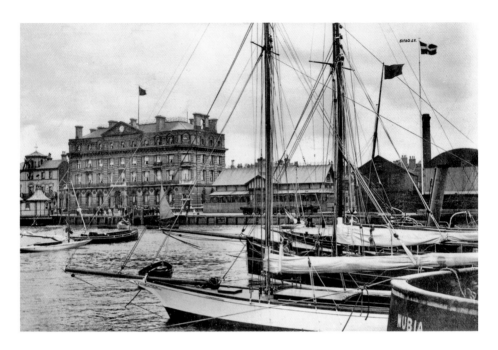

GER Hotel and Harbour, Harwich, *c.* 1916

Opened in 1865 by the Great Eastern Railway to provide luxury accommodation for Continental travellers, the hotel was never commercially very successful. In the First World War, it became the garrison hospital when Harwich was an important base for destroyers and submarines under Commodore Tyrwhitt's Harwich Force. Harwich and Dovercourt were both fortress towns, with no strangers allowed to enter. During the Second World War, it was again used by the Admiralty when destroyers, minesweepers and trawlers were based in the port. In 1951, it became the town hall and offices, but was converted into flats in 1988.

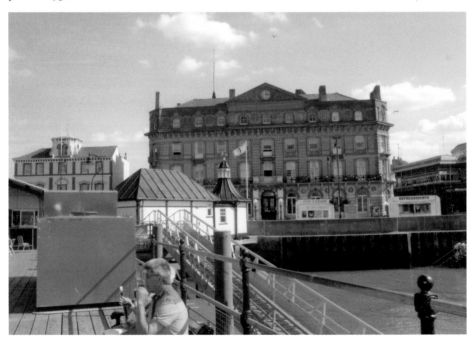

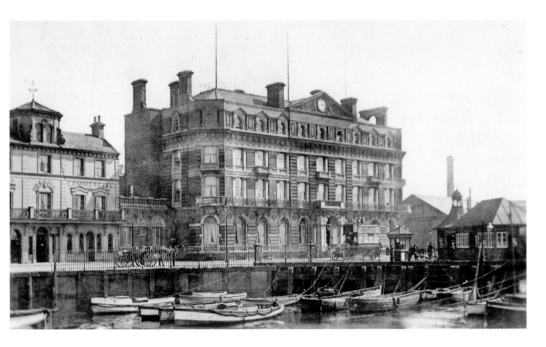

GER Hotel and Quay, Harwich, *c.* 1924

'We arrived in Harwich last night and moored up the river shall go across the water to Felixstowe today and may go to Ipswich by water tomorrow.' There is a magnificent open-topped motor bus outside the hotel. Built in the Venetian style in 1862, the Pier Hotel, next to the Great Eastern Hotel, has enjoyed better fortune than its larger neighbour and is still in business today, with first-class restaurants and accommodation. The hotel has acquired the former Angel public house next door to provide additional bedrooms.

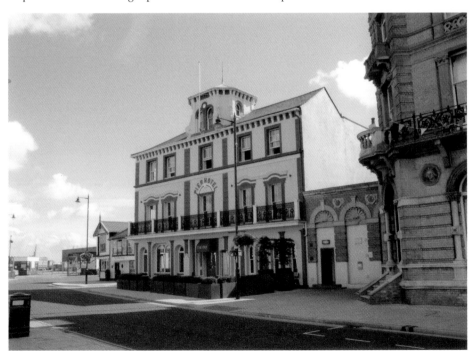

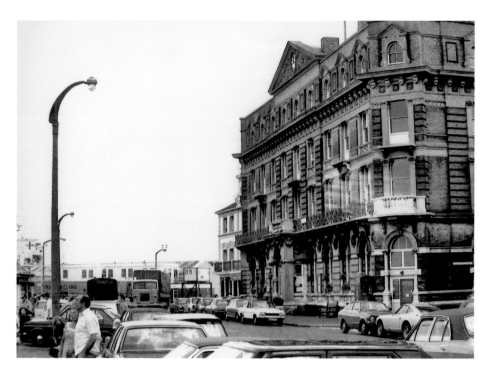

The Town Hall, *c.* 1980

T. West Carnie, writing *In Quaint East Anglia*, published in 1899, liked Harwich, although he didn't find it 'pretty'. 'I am fond of Harwich. It is such an out-and-out seaport, and makes no attempt at being a watering-place. A mere landsman feels rather ashamed of himself in so nautical a town.'

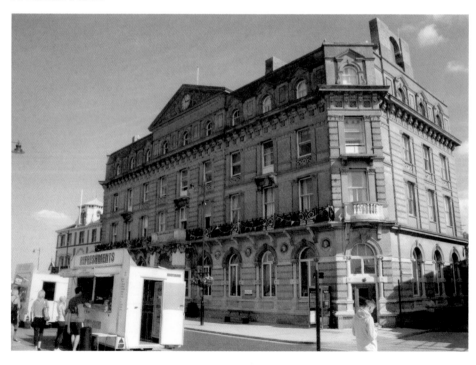

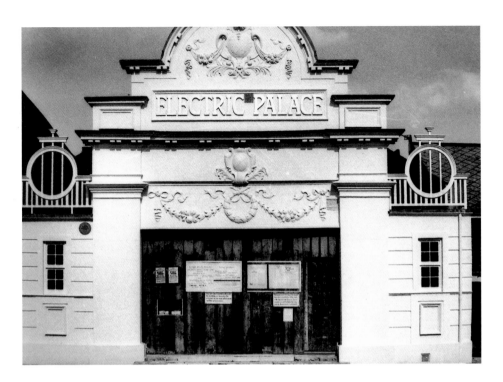

The Electric Palace, c. 1980

A short walk from the quay along Kings Quay Street is the Electric Palace, built in 1911, which makes it the oldest unaltered operational cinema in the country. When I first saw it, the cinema had just been restored by the Harwich Electric Palace Trust, after being closed in 1956. Today, it runs a busy programme of films and live entertainment, as well as being a venue for weddings and private functions.

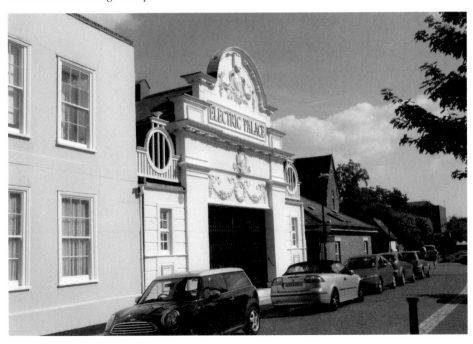

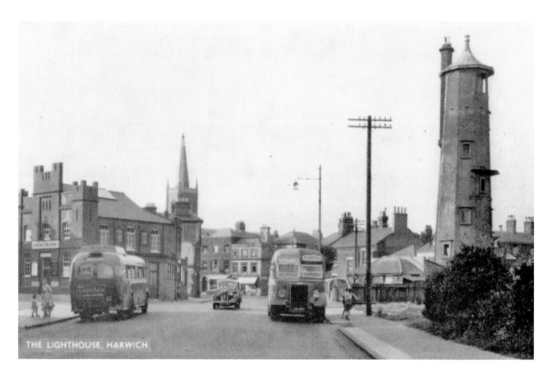

THE LIGHTHOUSE, HARWICH

The Lighthouse, Harwich, *c.* 1960
The High Lighthouse is one of a pair built in 1818, replacing earlier wooden ones. By lining up the light on the lower lighthouse (*see page 18*) with the High Lighthouse, mariners could find the safe channel into the port. The Salvation Army Citadel on the left was built in 1892.

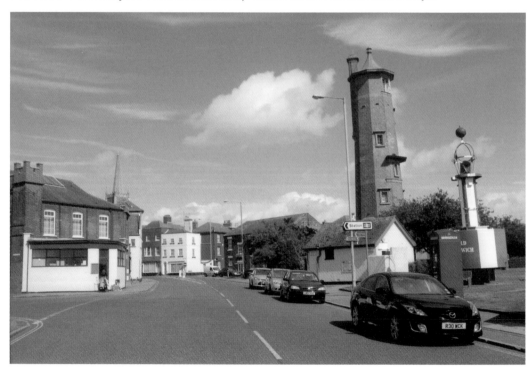

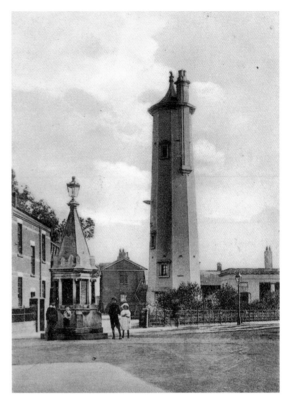

The Lighthouse, Harwich, *c.* 1912
Originally built and owned by General
Rebow, the two lighthouses were
bought by Trinity House in 1836, but
became redundant in 1863 as the
channel had changed course. In 1909,
the High Lighthouse was bought
privately, but remains one of the town's
most familiar landmarks.

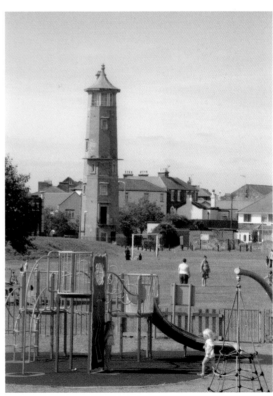

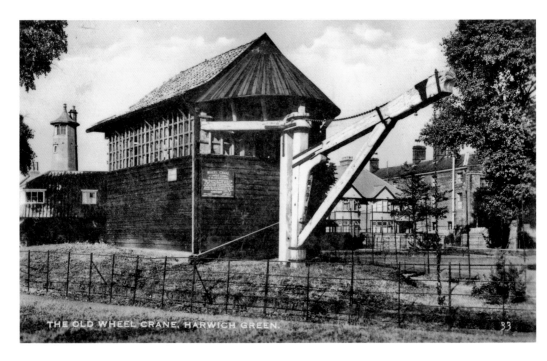

THE OLD WHEEL CRANE, HARWICH GREEN.

Treadwheel Crane, Harwich Green, *c.* 1945
There is nothing like it anywhere else! The Treadwheel Crane was built in 1667 and once stood in the naval yard, but was moved to this site in the early 1930s. Men walked in the interior of two large wheels, enabling the crane to raise and lower goods and materials. Harwich Green, on which it stands, and a large area of land along here was bought by the council from the War Department in 1930.

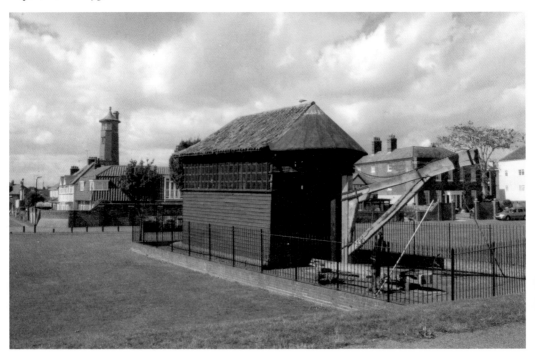

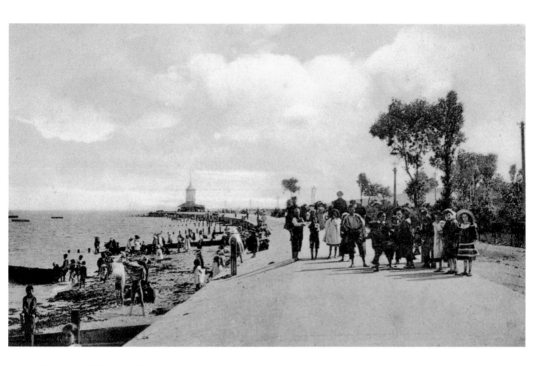

Beach and Parade, Harwich, c. 1910

In 1981, this section of beach was recharged with sand dredged from the harbour. The height of the new beach, while preventing sea damage to the promenade, has led to the development of a dune, which is being increasingly colonised by plants. Some rare local species, such as sea pea, sea spurge, lyme grass and the more common sea couch grass and marram grass, have now changed the whole nature of this section of the shoreline.

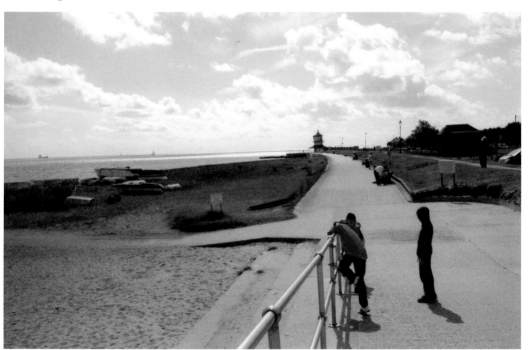

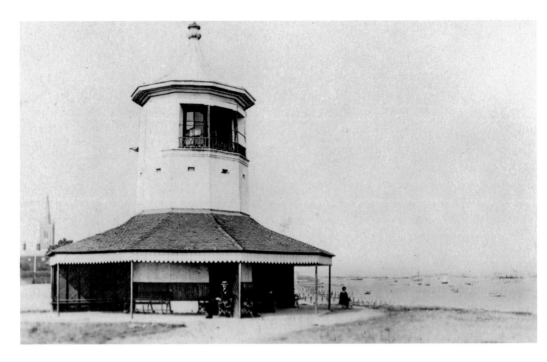

The Low Lighthouse, *c.* 1908
This is the forward companion to the High Lighthouse and was also built in 1818. Standing 30 feet high, it had three oil burners and reflectors. It also had the open, skirt-like shelter, which was a popular feature. After going out of use in 1863, it was used by Trinity House as a pilot station. Today it houses the Harwich Maritime Museum and, with its seating area looking across the harbour, provides a splendid place from which to see all the activity around the port and Felixstowe opposite.

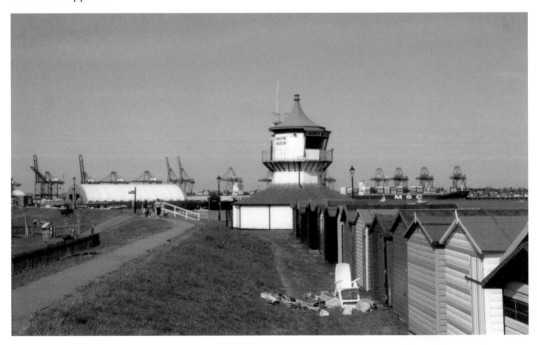

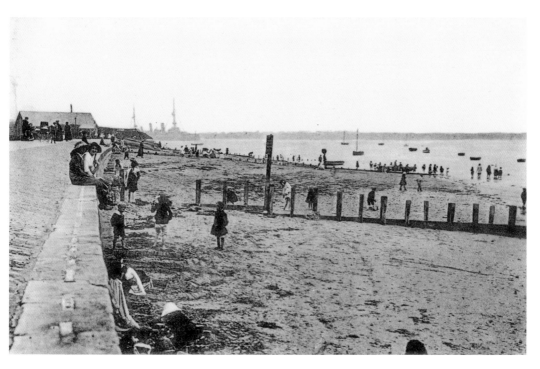

The Beach and Esplanade, Harwich, *c.* 1906
Another view that shows the changing nature of the beach with the emerging dune in the foreground. A popular beach in earlier times, it appears now to be more an area to walk beside and enjoy the harbour views, which are now dominated by all the cranes at the Felixstowe container port.

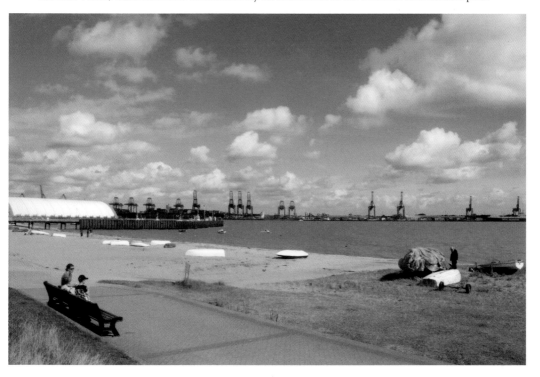

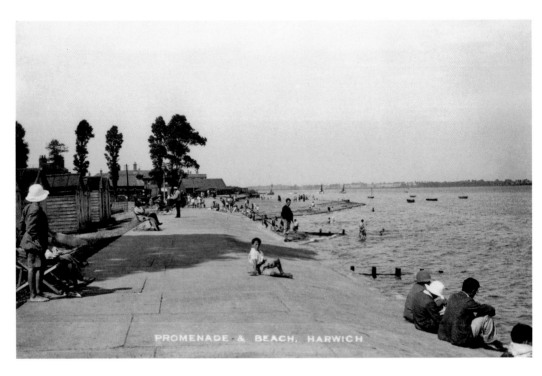

Promenade and Beach, Harwich
A view from the Low Lighthouse, looking back towards the port.

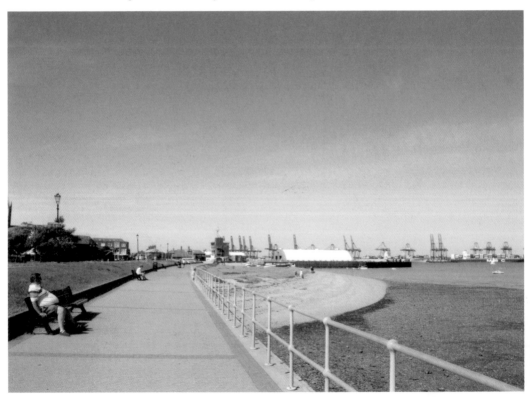

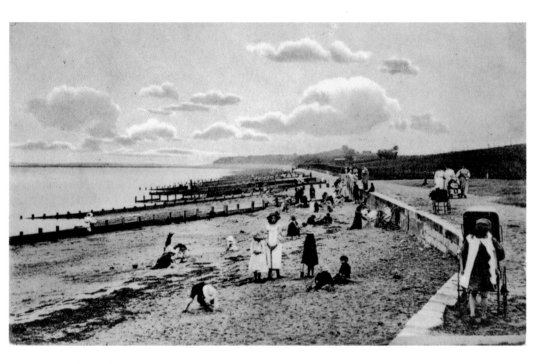

Harwich Sands, c. 1914

Posted on 28 August 1914, from Alec to Beckenham in Kent: 'Arrived here today after fine sail. We expect to go to Lowestoft tomorrow if we get permits to leave in time.' New sea walls, the promenade with its metal rails and the road behind now change the scene, but the rocky, pebbly beach with its little pools is still very popular for catching crabs when the tide retreats. T. West Carnie in the 1890s described this approach as 'its prettiest corner, though I am afraid a great many people would not admit that any corner of Harwich is pretty'.

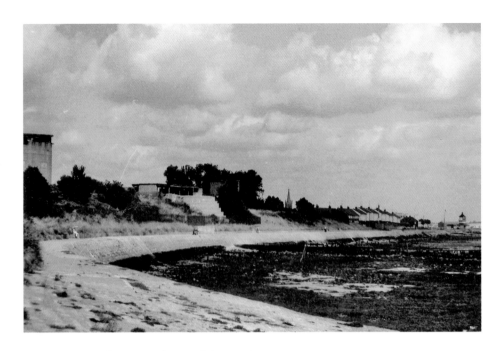

From Beacon Point Towards Harwich, *c.* 1980

This section of the British Coast has always been in the front line when it came to facing threats of invasion from Europe. Both Felixstowe and Harwich have large redoubt forts, built when there were fears of French invasion during the Napoleonic years. In 1889, the Beacon Hill battery had powerful guns on carriages that could be concealed in pits, and these defences, strengthened during the two world wars, still dominate the skyline at Beacon Point. Grim, gaping and gaunt, and now an ancient monument, they are a reminder of how important Harwich was as a wartime naval base.

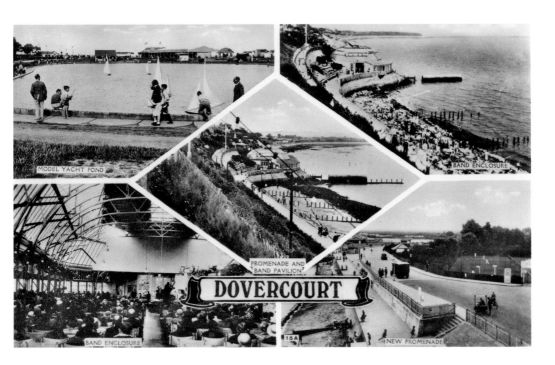

Dovercourt, c. 1938
The imposing statue of Queen Victoria was paid for by public subscription and unveiled in 1904 by the Earl of Warwick, Lord Lieutenant of Essex. Carved in Carrara marble, the Queen stands with her back to the bay, staring imperiously down Kingsway towards the town centre.

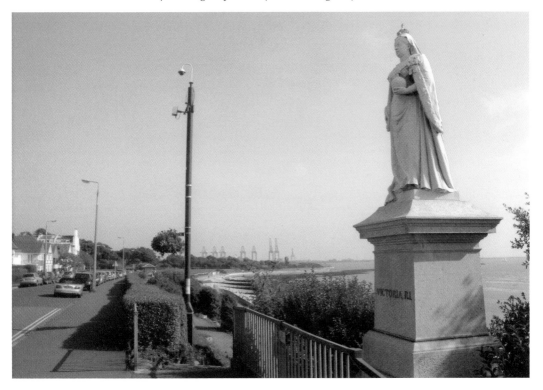

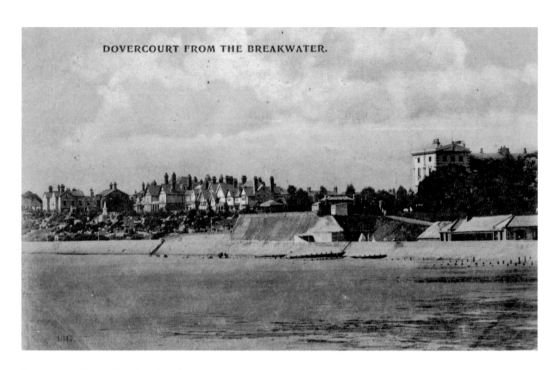

DOVERCOURT FROM THE BREAKWATER.

Dovercourt from the Breakwater, *c.* 1906

Queen Victoria can be seen in this early panorama of the bay. This is where John Bagshaw began his new seaside resort in the early 1850s. His spa buildings are to the right underneath the end of Orwell Terrace. The breakwater, which was originally planned to be 800 yards long to protect Harwich Harbour from being blocked by shingle banks, was constructed from Kent ragstone from 1846 and stopped at some 520 yards in 1850.

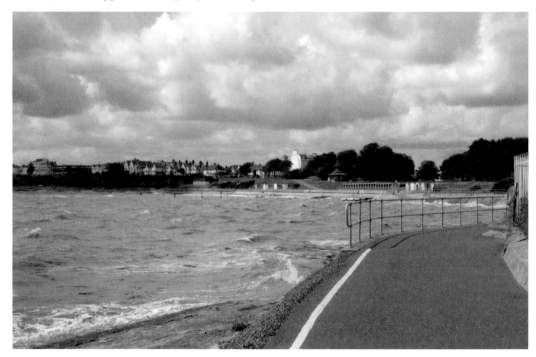

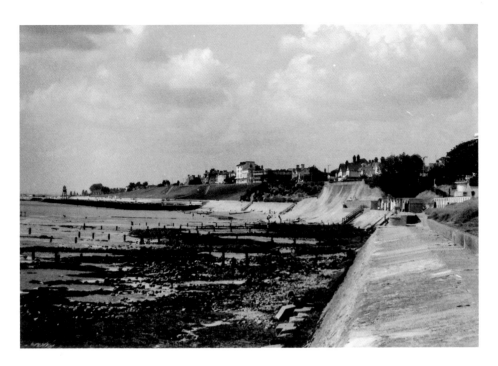

Dovercourt from the Point, *c.* 1980

Sea defences have been strengthened and improved all along the East Anglian coast, especially after the terrible floods of February 1953, when Harwich was badly hit, resulting in the loss of eight lives. A major scheme in sea defences and a new promenade, which can be seen in the photograph below, was completed in 1989. A welcome improvement over the years has been the construction of a superb promenade and cycle way, forming part of the longer coastal route.

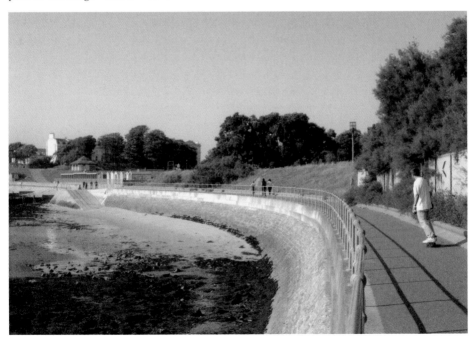

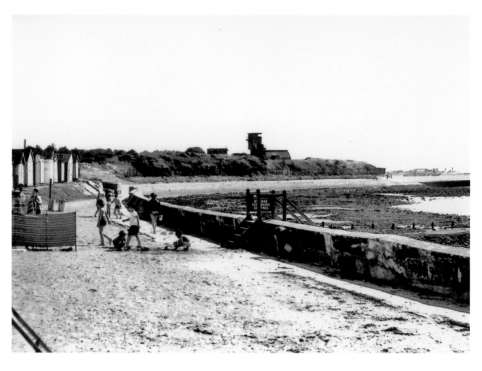

Beacon Hill, *c.* 1980
The beach huts and nearby Cliff Park make this a popular part of the bay. It surprised me how, since my visit there in 1980, the dockyard cranes at Felixstowe now completely dominate the skyline, dwarfing the gun emplacements on Beacon Hill.

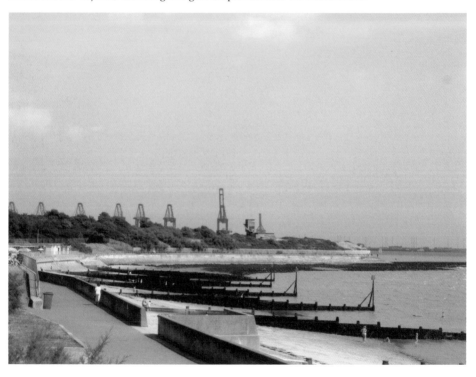

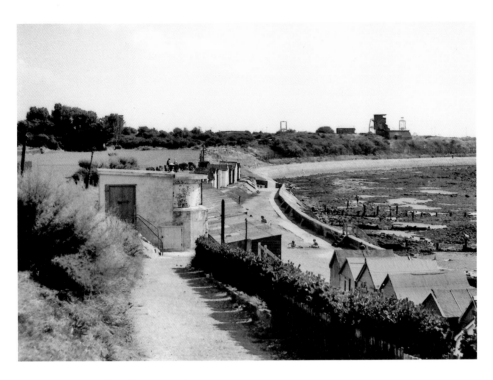

Dovercourt, Looking East, *c.* 1980
Improvements to the promenade and the removal of earlier buildings can again be seen, as well as the parkland above, where John Bagshaw built his large residence and began developing his plans for a new, fashionable, south-facing watering place on the east coast cliffs of the bay.

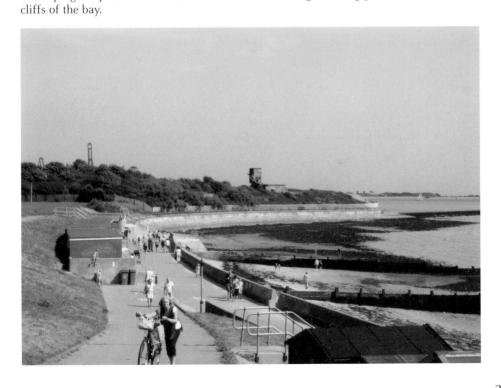

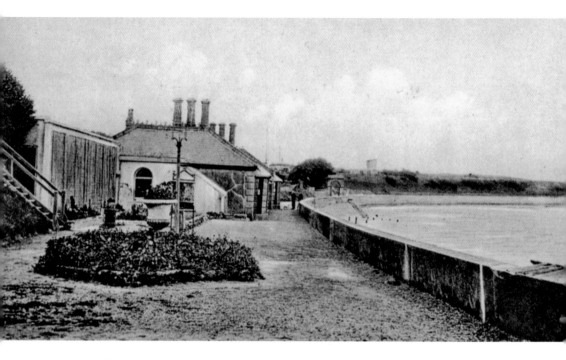

Dovercourt Spa, c. 1912
John Bagshaw built his mansion in 1845 and fortuitously discovered a spring in the extensive grounds. The spring, it was claimed, had chalybeate properties, and a new spa was built with pump room, museum, reading room and library. C. S. Ward visited in the 1880s and described the spa as 'more patronised as a lounge than for the waters (mild tonic)'. In the distance can just be seen the stone arch for one of the four gates providing entrances to the park, so that a charge could be made for admission to concerts or firework displays.

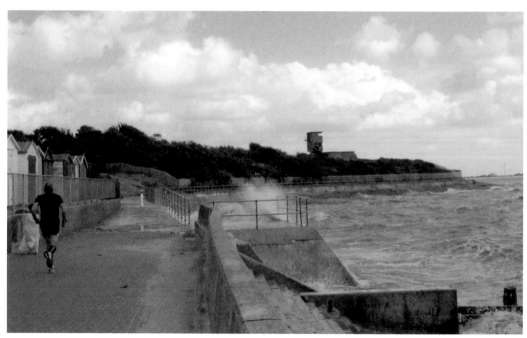

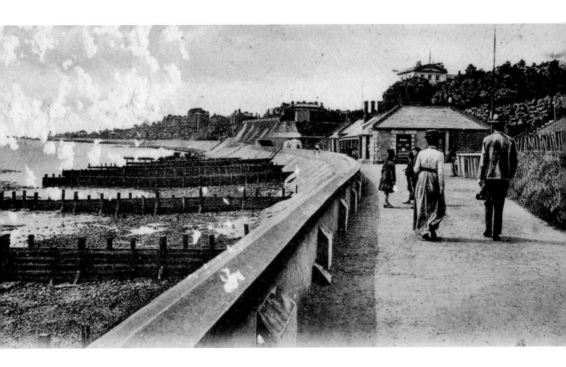

The Spa, Dovercourt, c. 1904

T. West Carnie, who visited in the 1890s, gives a similar view describing the spa as 'quaint'. 'I don't know whether anyone takes the waters here – they are supposed to be similar to those at Tunbridge Wells – but we have to thank the spring for the existence of this cosy little retreat.' Payment of one penny gave you entrance to the pump room, reading rooms with newspapers and magazines, smoking room, library and conservatory. The spa was demolished in 1920.

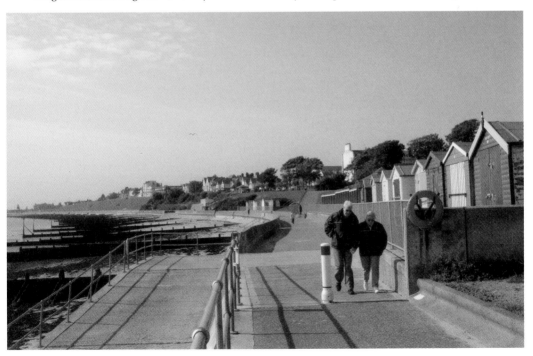

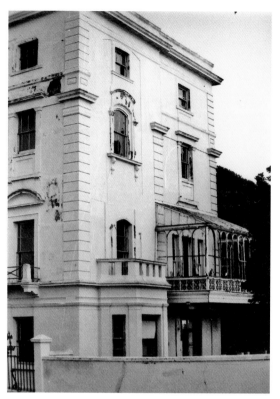

Orwell Terrace, c. 1980
John Bagshaw's architect, W. H. Lindsay,
drew up impressive plans for the new
watering place for the gentry. Orwell
Terrace, completed in the 1850s, ran
alongside the grounds of Bagshaw's Cliff
House. Bagshaw's son Robert, who was
also MP for Harwich from 1857–59, lived
in the house at the seaward end, seen
to the left, but sadly that has now gone.
Robert Bagshaw continued development
in Dovercourt, building Victoria Terrace
and the Kingsway Mission Hall in 1874.

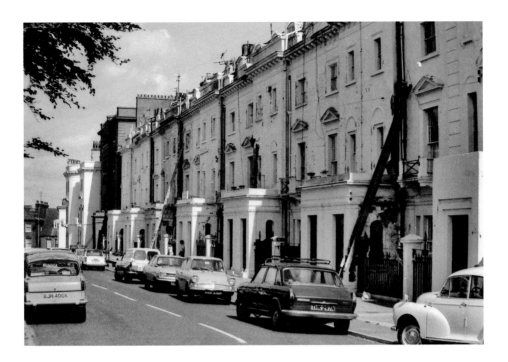

Orwell Terrace, *c.* 1980

John Bagshaw overreached himself financially and was bankrupt by the time of his death in 1861. As a result, his vision and Lindsay's grand designs did not go much further in terms of buildings, so this terrace is a reminder of what might have been all along the seafront as far as the Cliff Hotel. Recently, the town has received a Heritage Lottery Grant for restoration work in the Conservation Area, so hopefully some of the historic buildings will have a new lease of life.

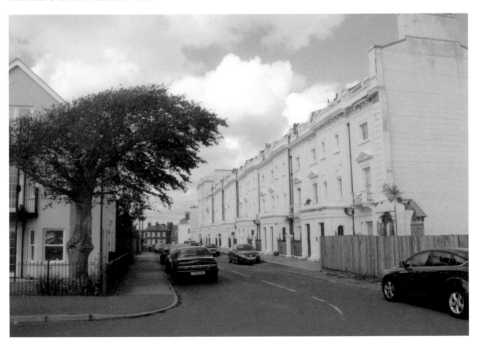

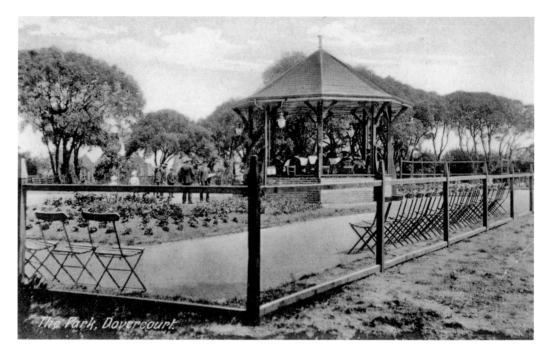

The Park, Dovercourt, *c.* 1912
Cliff House was demolished, but the grounds were bought by the Corporation and Cliff Park was opened in 1911 as part of the celebrations for the Coronation of King George V. The bandstand became a popular attraction, as huge crowds would gather to listen to the concerts. There were firework displays on Wednesday evenings in the park, and the Sunday afternoon concerts could attract as many as 2,000 spectators.

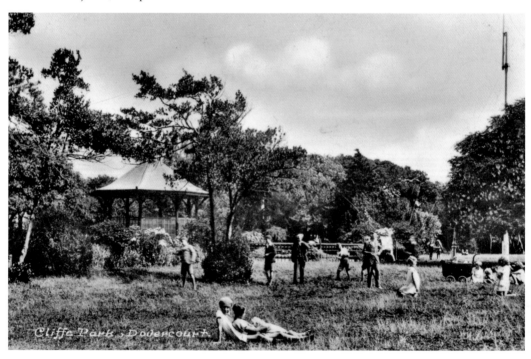

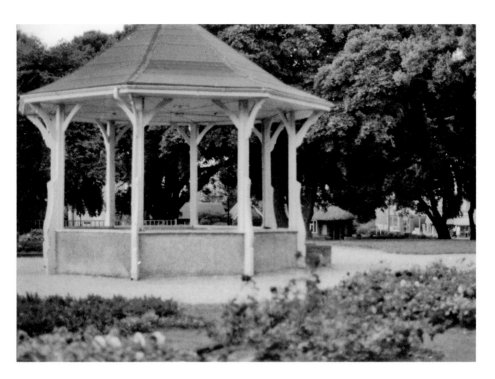

The Bandstand, *c.* 1980

After some years of little use, a concert by the Harwich Royal British Legion Band in 2009 and a local campaign led to a restoration of the bandstand in 2011, with help of a £5,000 grant from the Essex Heritage Trust. Cliff Park is a busy and popular recreational space with a good children's play area.

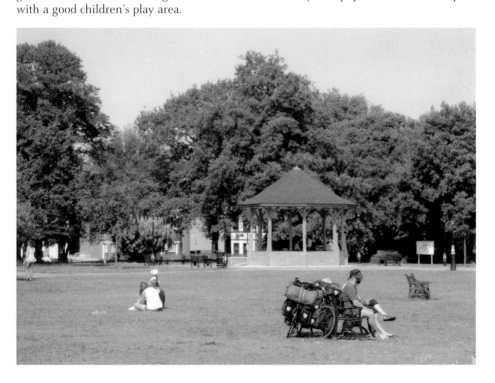

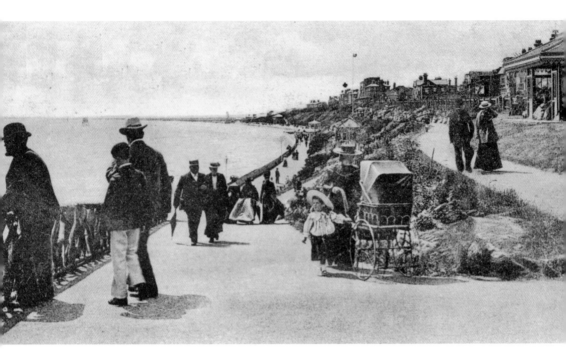

Dovercourt Slopes, *c.* 1903
John Bagshaw landscaped the cliff slopes leading from the end of Orwell Terrace with a fine shelter, path at an upper level and a broad sloping path down to a new promenade. The expense of all this work greatly contributed to his bankruptcy. Around the time this view was taken, William Friese-Greene (1855–1921), the pioneer of early film making, was living at No. 5 Cliff Road with his family. They lived there from 1897–1904.

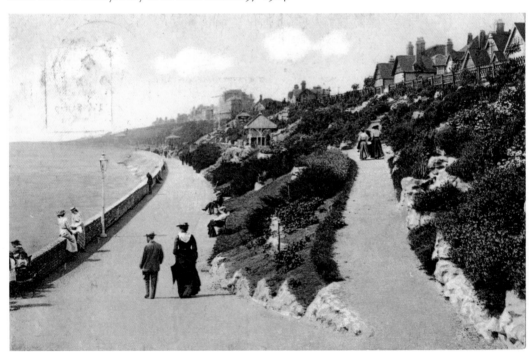

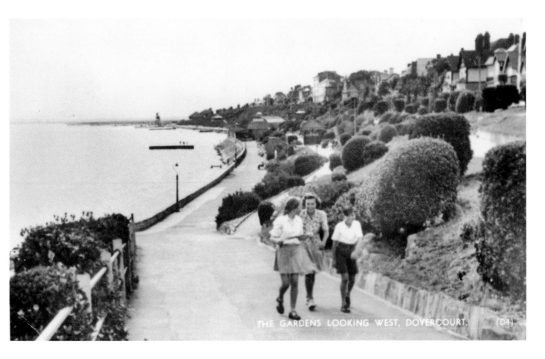

The Gardens, Looking West, Dovercourt, *c.* 1953
'Now sitting on the cliffs enjoying summer sunshine out of the wind, really hot. Not many people about except retired people and children. Sea quietly lapping the beach. Rather misty...' It would be true to say that I arrived late in the season, but sixty years on and I could say the same thing.

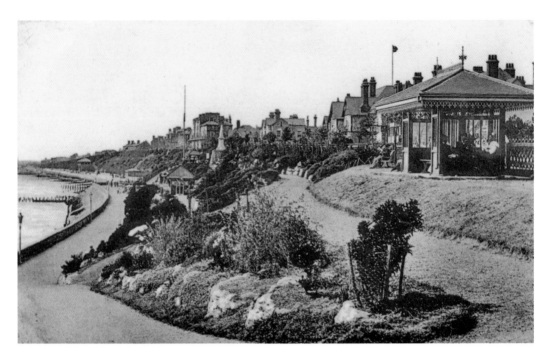

Cliff and Shelter, Dovercourt, *c.* 1914

Posted on 20 August 1914 from Sapper Betts, Great Eastern Hotel, Harwich, to his sister in Bletchley: 'Just a line in answer to your letter ... I am in hospital with a very bad cold have been in 3 days but I am going on very nicely, expect to be out in a day or two. Remember me to all at home...' Britain had been at war with Germany since 4 August, and the area was busy with soldiers waiting to go to France. The Great Eastern Hotel was already in use as a hospital.

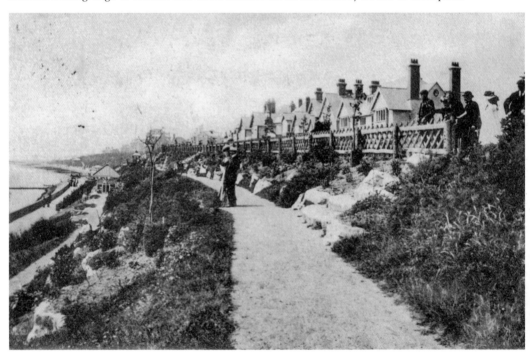

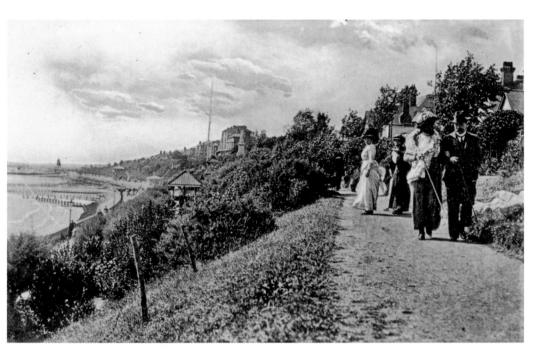

Gardens Looking West, Dovercourt Bay, c. 1910
Dovercourt was ideal for promenading, with its clifftop walks and landscaped gardens, seats and shelters. It is impossible to tell whether the two ladies turning to look back are intrigued by the photographer or the fine-looking couple they have just passed. In 1900, the council bought the cliff slopes and sea wall from the trustees of John Bagshaw and extended the promenade as far as the lighthouse.

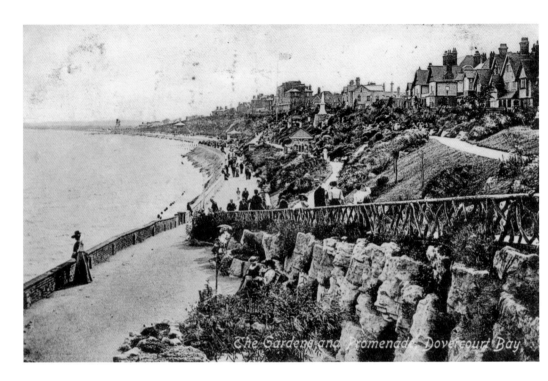

Dovercourt Bay, c. 1912

The view below dates from around 1912. 'I have been down here for three weeks staying with my aunt ... I feel all the better for my holiday.' By the time this was written, the idea of going to the seaside for your health was firmly established and this is a repeated theme in postcard messages. The Hotel Alexandra can be seen on the Marine Parade.

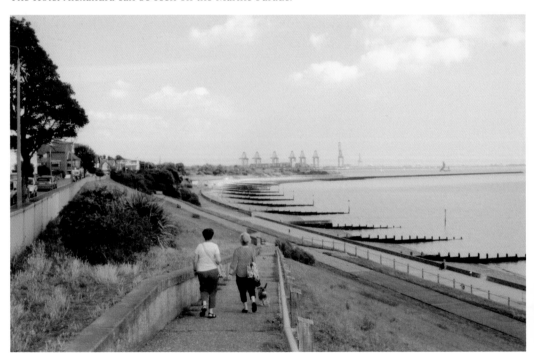

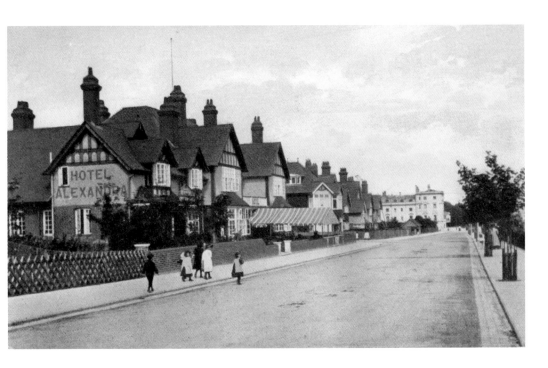

Dovercourt, the Upper Esplanade, c. 1908
The Hotel Alexandra was opened in May 1903, and was regarded as the finest in the town, even boasting of royal patronage after King Edward VII visited in 1905. There was a dining room, drawing room and billiard room on the ground floor, plus a restaurant that could be entered from the street. An oak staircase led to some forty bedrooms. A feature of the hotel was a 500-seat theatre. Still very recognisable, it is now the Alexandra House care home for the elderly.

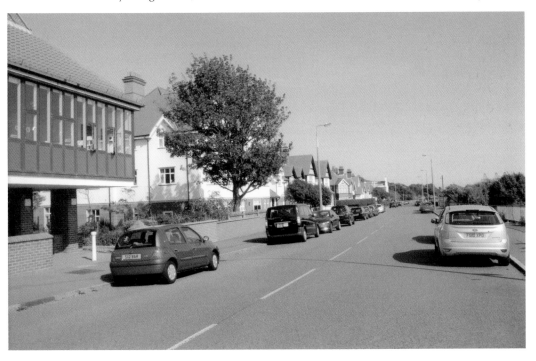

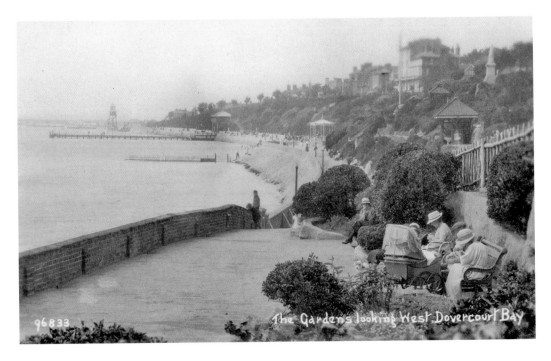

96833 The Gardens looking West Dovercourt Bay

The Gardens Looking West, Dovercourt Bay, *c.* **1924**
A charming photograph that captures a small group in perhaps a sheltered but sunny spot, feeding the baby. These photographs show the old wall that ran along the edge of this section of the original promenade. Below is an artfully composed picture with the man leaning on the sea wall. He appears on more than one photograph in this Kingsway series of photographic postcards from around 1909.

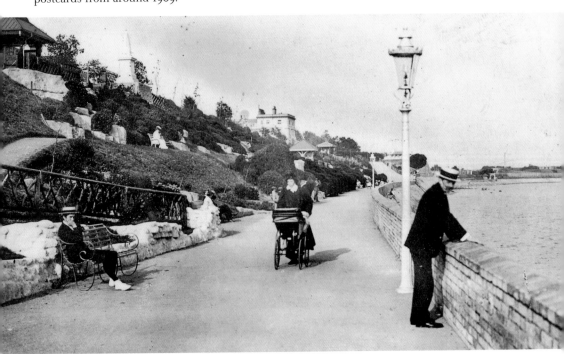

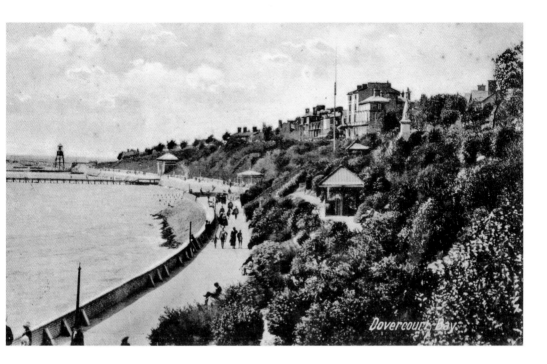

Dovercourt Bay, c. 1925

As the early publicity for the resort says, Dovercourt can be 'breezy', which is another way of saying windy, or as they used so successfully in Skegness with John Hassall's 'Jolly Fisherman', 'bracing'. Three of the four shelters along the seafront that have now gone can all be seen in this long shot following the curve of the bay. It also shows the amount of planting all along the slope of the cliff, which is still there in the oldest part of the promenade, but replaced by grass slopes further along.

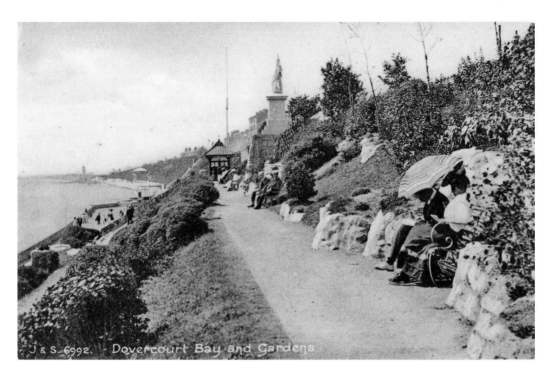

Dovercourt Bay and Gardens, *c.* 1910
Over 100 years separates these two photographs. The shelter in the distance has been removed, but pausing to sit and look at the sea is timeless.

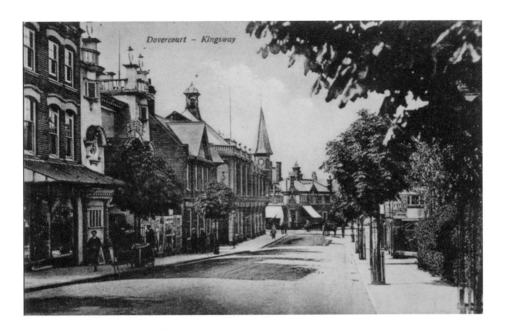

Dovercourt – Kingsway

Kingsway

Kingsway leads from the centre of the High Street to the Marine Parade and Queen Victoria. Until 1903, it was known as Stour Road. The Empire Cinema stood on the left from 1913–38. Below, the tall tower of Robert Bagshaw's Mission Hall, built in 1874, can be seen on the right. It closed as a church in 1984. The Kingsway Hall Arts and Theatre Trust took over the building in 1999 and, in autumn 2011, it had a major revamp as an arts venue.

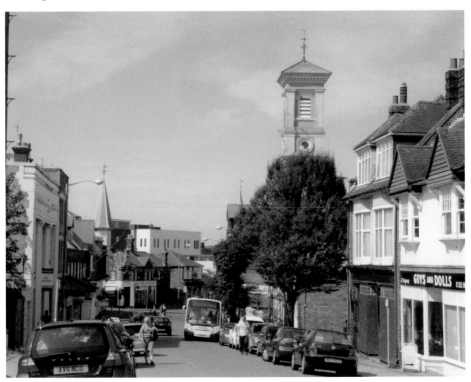

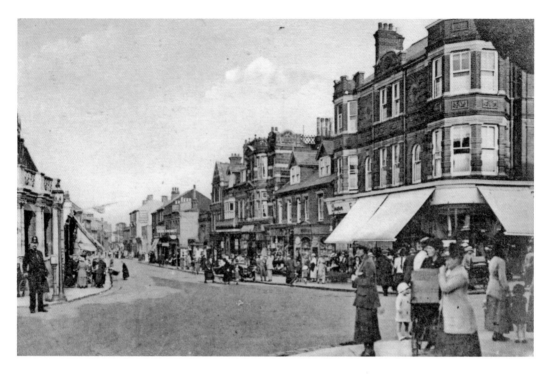

High Street, Dovercourt, *c.* 1921
There was a large Co-op alongside where the photographer is standing on the corner of Kingsway, and many other fine stores and cafés. Like most high streets throughout the country, Dovercourt has been affected by out-of-town supermarkets.

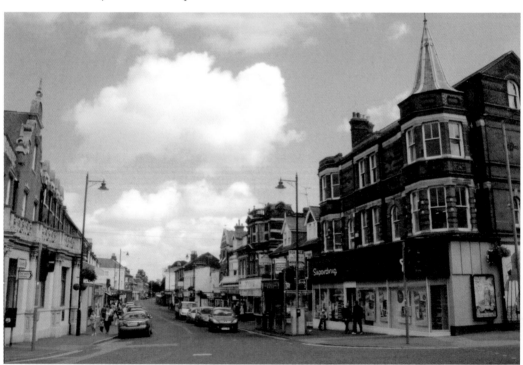

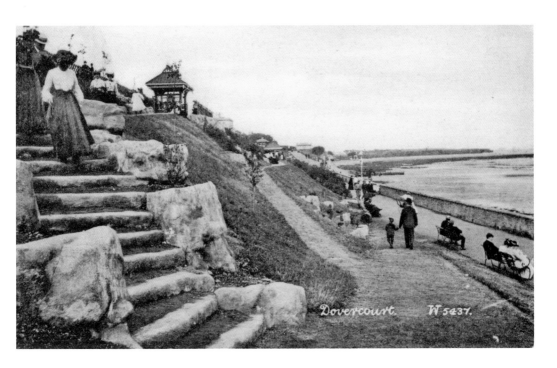

Dovercourt, c. 1910

The expensive and artistic landscaping of paths and steps along and down the cliff at Dovercourt helped make the resort a fashionable and popular place. I wondered if the stone used was Pulhamite, a mix of sand, shale and cement developed by James Pulham & Son and used at Felixstowe, but Dr Kate Felus and colleagues who carried out a survey for Essex County Council in 2008 were unable to confirm this, so it may well have been some local substitute. In places, it is now in a poor state and it is difficult to make out the earlier features.

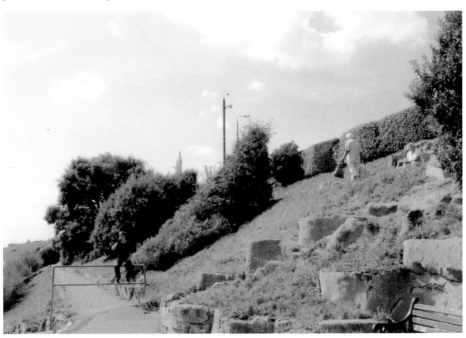

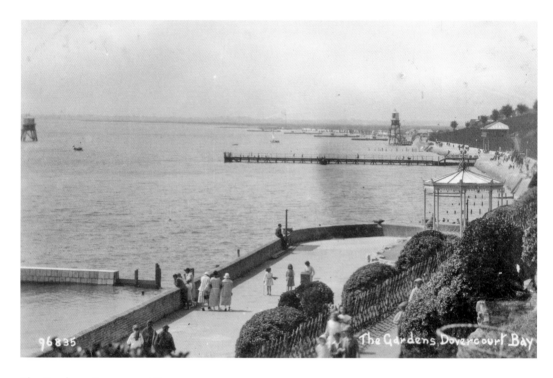

The Gardens, Dovercourt Bay, *c.* 1925

From Alice to her friend Edie in Kentish Town, 27 July 1925: 'Are you getting excited about your holiday? I hope you will have a good time. I am writing this under difficulties as Jack and Stan keep bumping into me. I am off to Felixstowe tomorrow. The time is going quickly worse luck...' The image below is earlier, around 1909, and shows the bandstand more clearly.

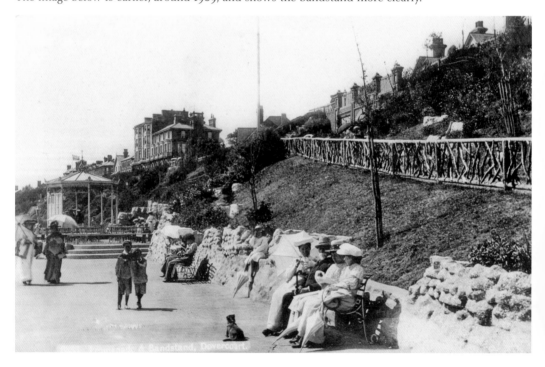

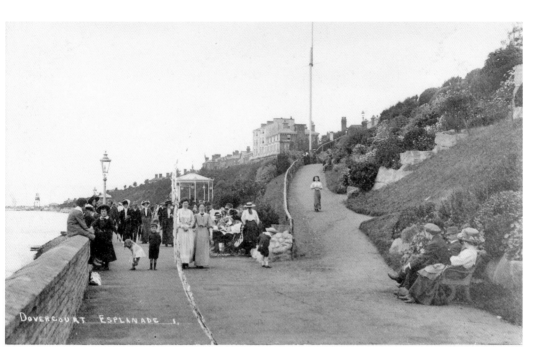

The Bandstand, Dovercourt, *c.* 1912

The bandstand was given to the town by the Co-operative Society in 1902. Those walking the promenade have paused for the photographer and present a tableau of Edwardian fashion. Like the photograph that follows, there are girls in their wide-brimmed bonnets, boys with floppy-brimmed hats or caps, the men in suits and the ladies in their fine long dresses and, in this photograph, their hats sensibly held in place by their scarves. Dovercourt Bay would advertise itself 'on the sunny and breezy east coast'.

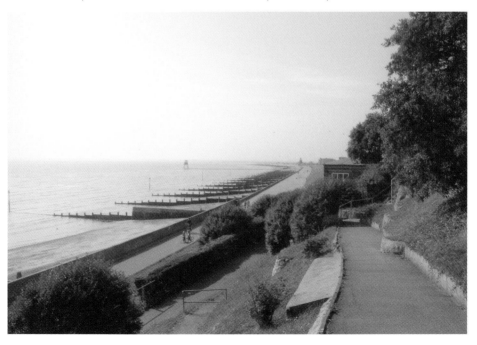

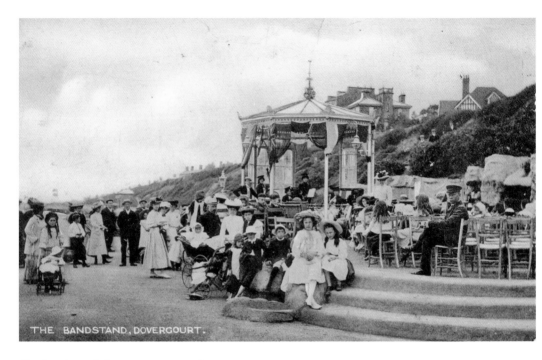

The Bandstand, Dovercourt, *c.* 1908

The band appears to be all female and, like the crowd gathered for the concert, they too are pausing to smile for the camera. In 1935, Dovercourt claimed to be the sunniest resort in Great Britain and in 1936, the sunniest resort on the east coast. In 1929, a new enclosure was opened around the bandstand, giving those hundreds who gathered to listen to the bands some protection from the wind. In 1932, the enclosure was transformed into the new Cliffs Pavilion. With seating for some 330, it became a popular venue for a variety of concerts and entertainment.

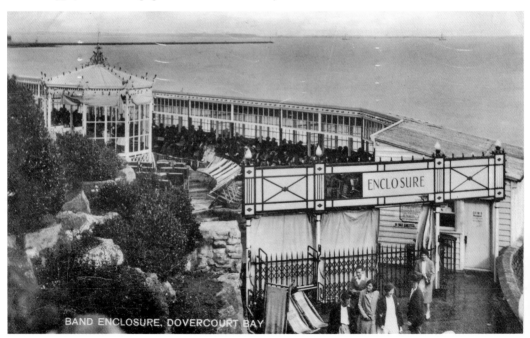

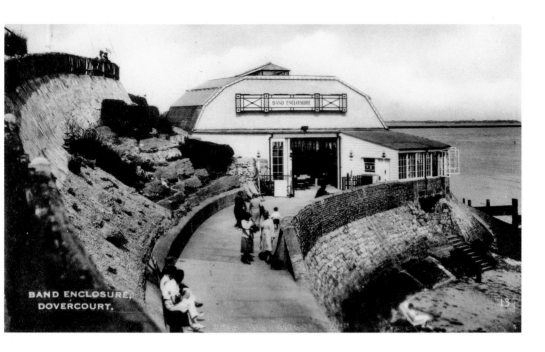

The Band Enclosure, Dovercourt, c. 1938

The bandstand was removed and the new pavilion built in the style of a Central European Casino Winter Garden. Eugenie and his Magyar Orchestra are performing on the stage. A Dovercourt favourite, Eugenie played at the Royal Command Performance of 1932. For 6d admission, there were various themed nights, with Saturday night as party night. Sadly, by 1970 the holidaymakers were no longer staying in Dovercourt, and fears of the cliff slipping and the need to improve the sea defences by landscaping the cliffs and building a wider promenade led to the pavilion being demolished in 1972.

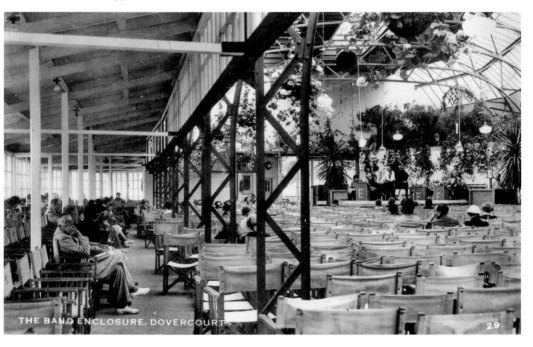

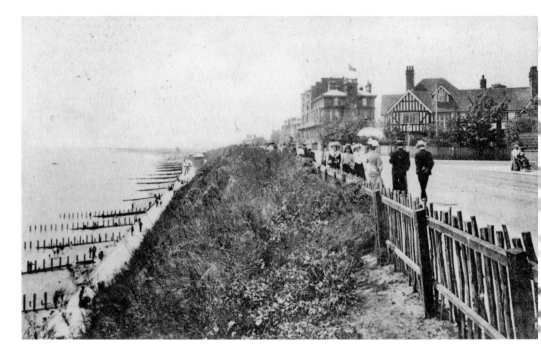

Dovercourt Bay, *c.* 1902

When Maud Homer visited the new watering place in 1865, they ate roast fowl for dinner and shrimps for tea, and went twice to church on Sunday. They visited friends and enjoyed rides on the donkeys. The Gables Hotel can be seen, but sadly this has gone and its replacement is the functional block of apartments, which retains the name, but none of the charm. In the lower photograph, from around 1912, beyond the Hotel Alexandra is Cliff Hall, which in 1938 became the Elco Hotel and café before it was demolished in 1972 and replaced by Wimborne House.

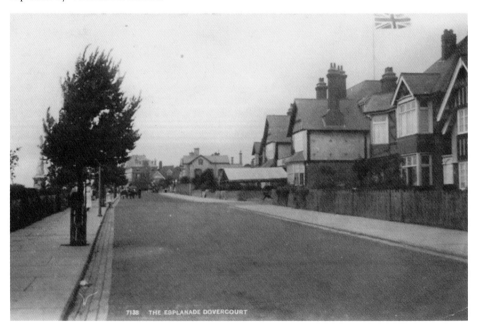

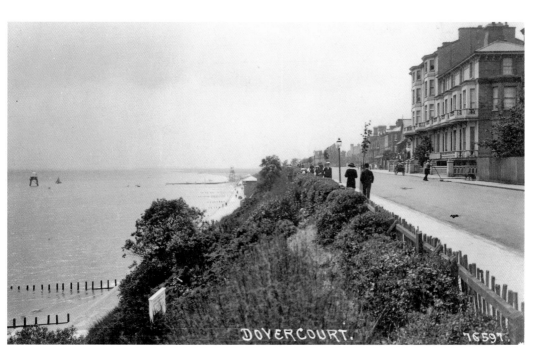

Dovercourt, c. 1914

One landmark along the Marine Parade that has been there from the earliest days of the new spa resort is the Cliff Hotel. Buildings have come and gone alongside, but it remains as a symbol of John Bagshaw's vision. The original Cliff Hotel dates from at least 1852 and was originally two properties, a house and a hotel. Maud Homer, her mother and friend Mary could not afford the two guineas a week at the Cliff for board only. Extensive changes were made in 1882, with the Victoria Hall built adjoining and later becoming the Cliff Hotel Pavilion.

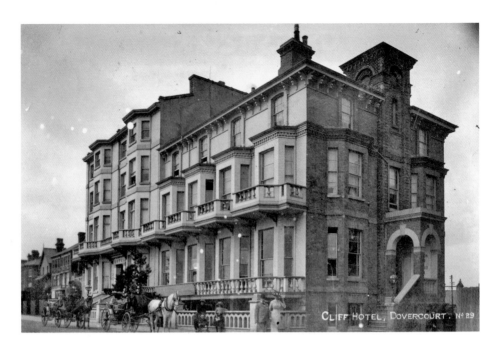

Cliff Hotel, Dovercourt, c. 1914

Horse-drawn carriages wait on the Marine Parade outside. In 1924, part of the hotel was refurbished as a Palais de Dance. What images that name brings to mind! Today, the Cliff is still very much in business, with twenty-six en suite rooms and all the modern facilities that might be expected, with the front-facing ones offering stunning views of the sea. The Marine Suite, the hotel's main function room, holds up to 220 people and the Millbay Restaurant overlooks the sea.

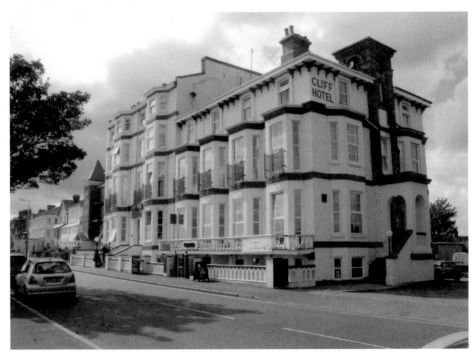

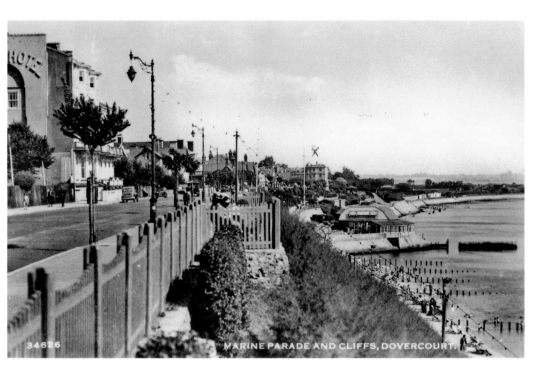

Marine Parade and Cliffs, Dovercourt, c. 1953
'We arrived safely at 2 p.m. yesterday. A good journey and comfortable digs [they were staying at 14 Orwell Terrace]. The sun has shone most of the morning here but is clouding over a little now. Air nice and fresh so the cobwebs will blow away.'

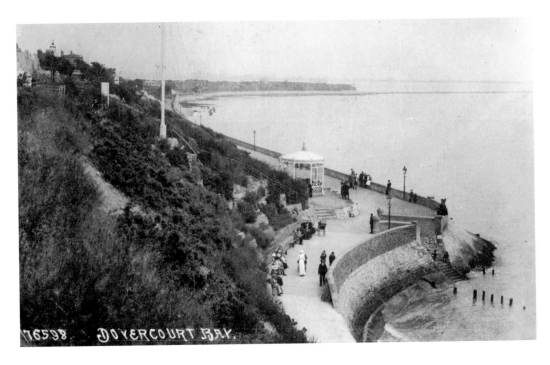

Dovercourt Bay, *c.* 1914

Written November 1914 to Leicester: 'Just a line to let you know I am in the pink and I hope you are the same. What do you think about raising a poor man's beer? He ought to be shot. We are having splendid weather over here but we cannot get any Germans ... with love from Ernest.' One can only wonder how long Private D. E. Ward stayed 'in the pink' in the years to come. Below, a similar view around 1939 with another war imminent.

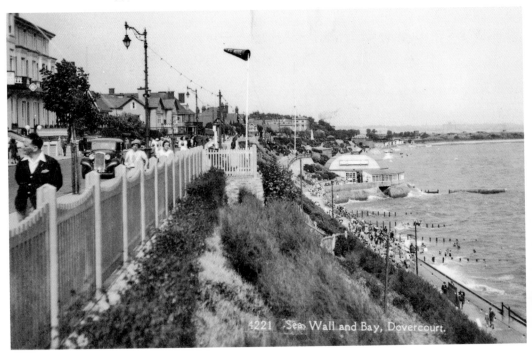

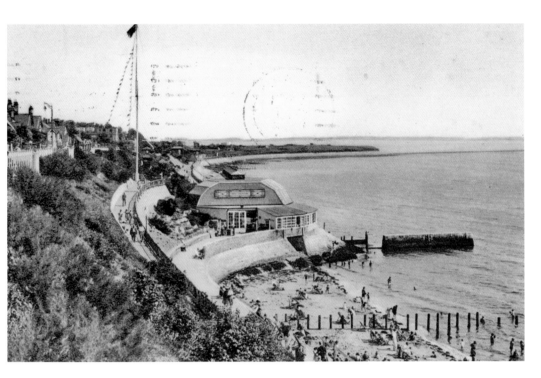

The Cliff Pavilion, Dovercourt Bay, *c.* 1934
'Have been here with Doris for two months. She had another daughter on April 14th (Susan). We return home on Sunday...' A photograph that clearly shows how the new Cliff Pavilion straddles the lower promenade.

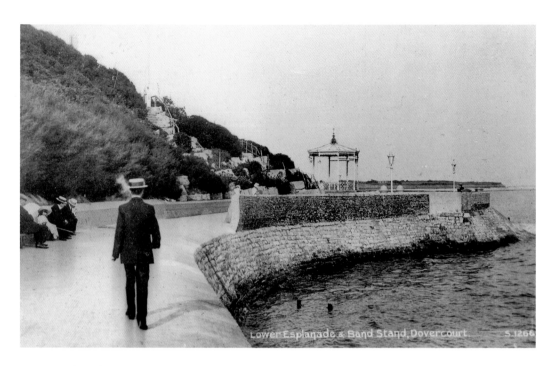

Lower Esplanade & Band Stand, Dovercourt

Lower Esplanade & Band Stand, Dovercourt, *c.* **1909**
Part of a fine collection of photographs in the Kingsway Series. The gentleman walking away from the camera in a cloud of cigar smoke also appears casually leaning on the sea wall and looking back at the camera in the Kingsway photograph of the Cliff Gardens.

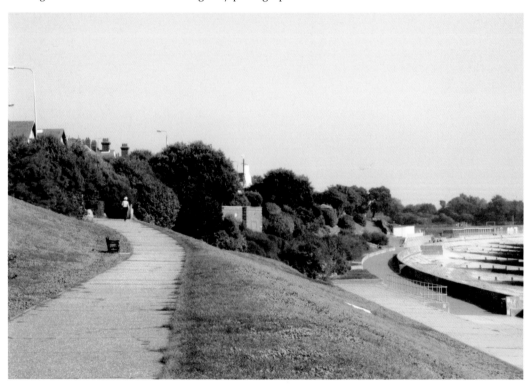

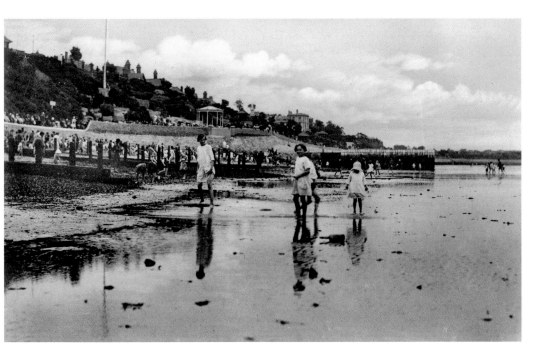

Low Tide, Dovercourt, *c.* 1920
A classic shot of children paddling in their ordinary summer clothes. The gently sloping nature of the beach makes it ideal for this simple pleasure. It looks as if the photographer himself has rolled up his trousers to get a different angle.

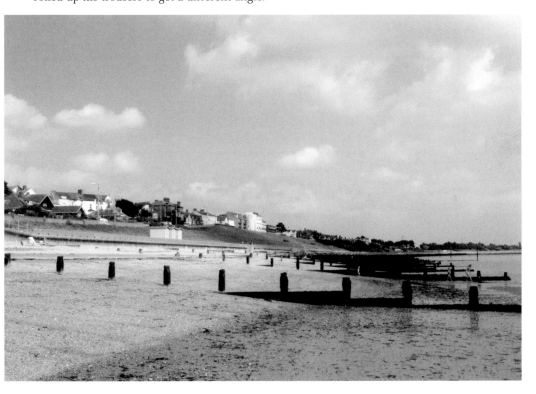

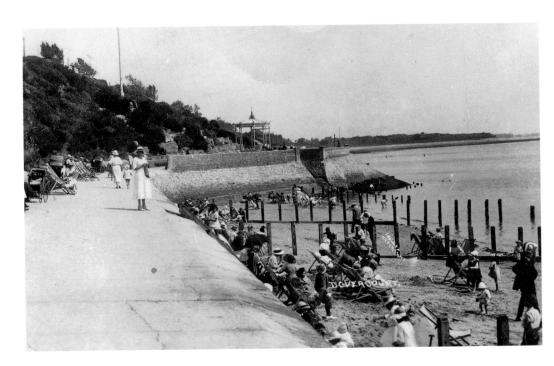

Dovercourt, c. 1923

Written by E. A. Marks to Market Harborough: 'Dear Sir, Thanks for P. C. Yes, my terms include Plain Cooking. Yours Truly...' The photograph is by Frederick Wallis, who had a studio and photograph kiosk in Dovercourt from 1920. He died in 1924. The postcard below was written in Dutch and sent to Holland, a reminder that for many in Europe, a trip on the ferry would take them to Harwich and a holiday in Dovercourt.

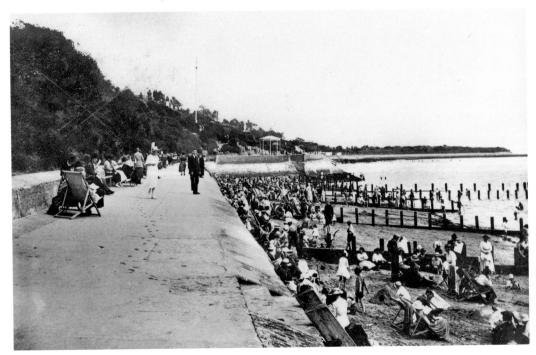

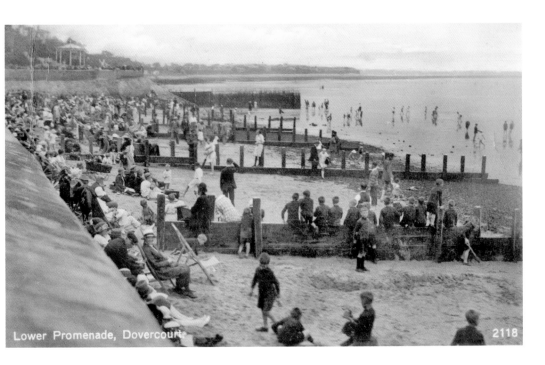

Lower Promenade, Dovercourt 2118

Lower Promenade, c. 1925
A photograph that reminds us that even a fairly modest resort like Dovercourt could attract thousands of trippers and holidaymakers during the summer. The Bank Holiday Act of 1871 must rank as one of the greatest social reforms ever. For many, August Bank Holiday meant a day at the seaside, and with the development of the railway network, it became possible for many working families to get their first sight of the sea and understand what it meant to live on an island.

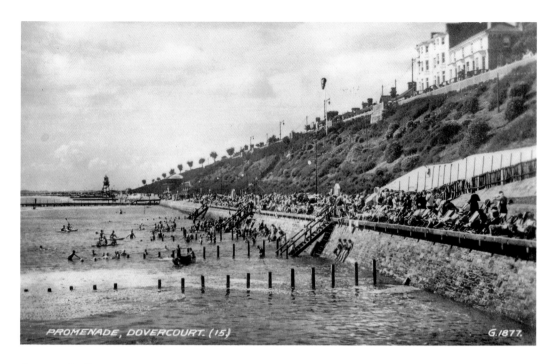

Promenade, Dovercourt, c. 1950

During the Second World War, when, of course, Harwich and Dovercourt were closed to visitors, there were 1,200 air raid alerts for the Borough of Harwich, and residents witnessed the activities of the British fleet and the damage that German mines did to shipping. After the war, the holidaymakers returned in great numbers, bringing their ration books with them. Dovercourt boasted of being the sunniest resort in the country. In 1949, there were 1,930 hours of sunshine recorded.

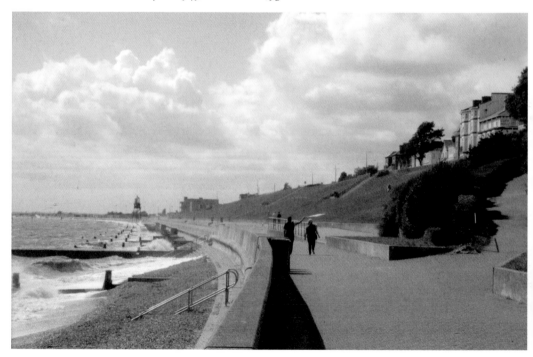

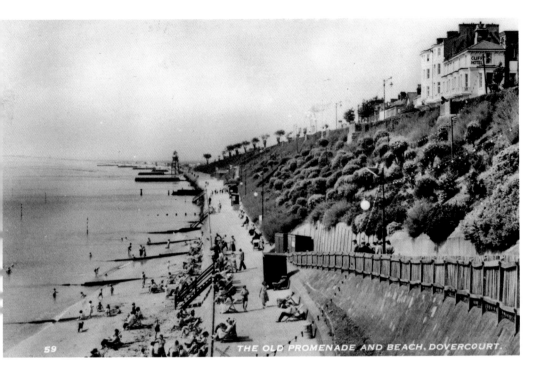

The Old Promenade and Beach, c. 1950

The wooden steps that once ran down from the promenade to the sands are shown clearly on both these photographs. The town guide for 1951 promotes Dovercourt Bay 'For Health Sunshine and Comfort'. The resort has 'safe bathing, sandy beaches, fishing; tennis; bowls; boating; putting green; bands, concerts, dancing; and open air roller skating rink and model yacht pond'.

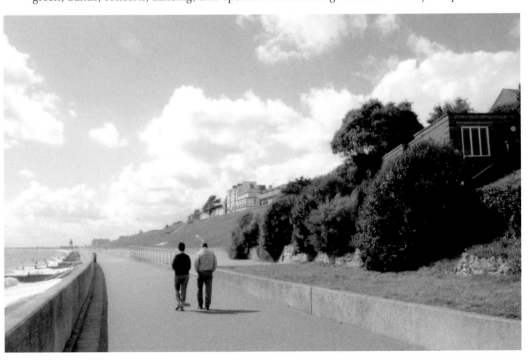

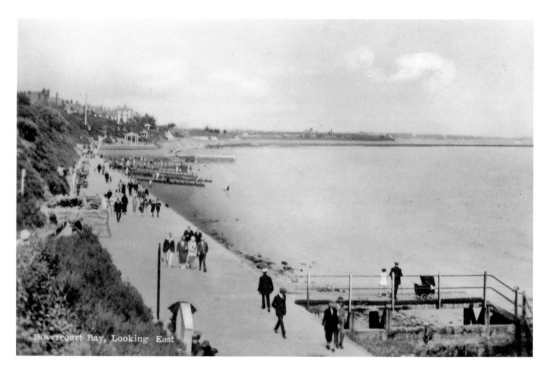

Dovercourt Bay, Looking East, *c.* 1925
Earlier in the century, many people hoped that Dovercourt would have a pier. It did have two jetties, more modest but very practical and popular structures.

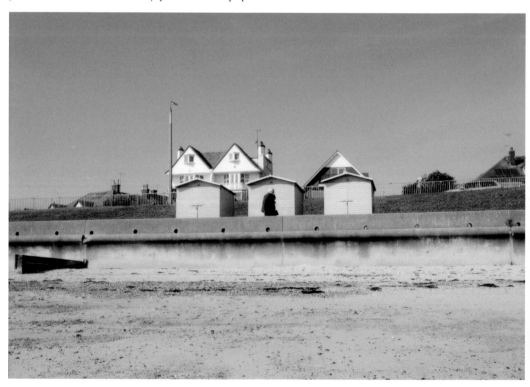

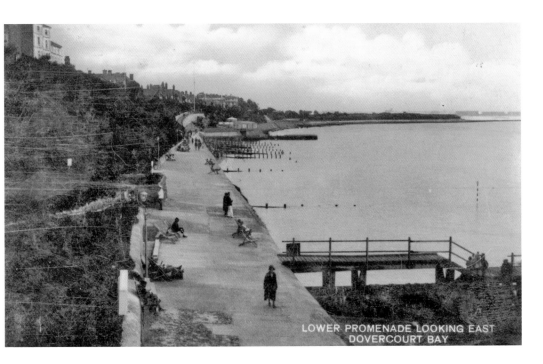

LOWER PROMENADE LOOKING EAST
DOVERCOURT BAY

Lower Promenade, Looking East, Dovercourt Bay, c. 1930
The jetty has long gone and the greatly increased width of the promenade has left an open and rather featureless seafront. It is ideal for joggers and cyclists, and would have been ideal too for the thousands of trippers who once descended on the town between the wars and in the 1950s, before the lure of cheap foreign holidays in the sun brought such a change in fortune to the English seaside.

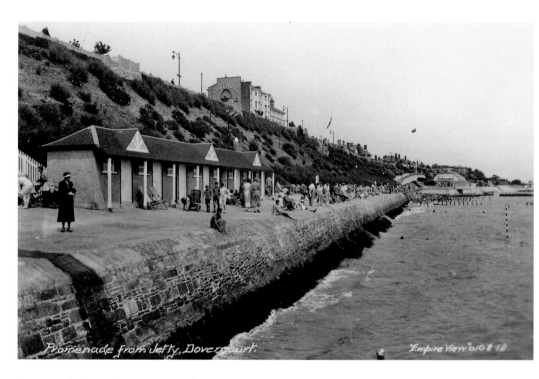

Promenade from the Jetty, c. 1936
The row of beach huts has been built by the council at the rear of the promenade, but the fine two-tiered Victorian shelter, which housed public toilets and at one time a small café, has gone.

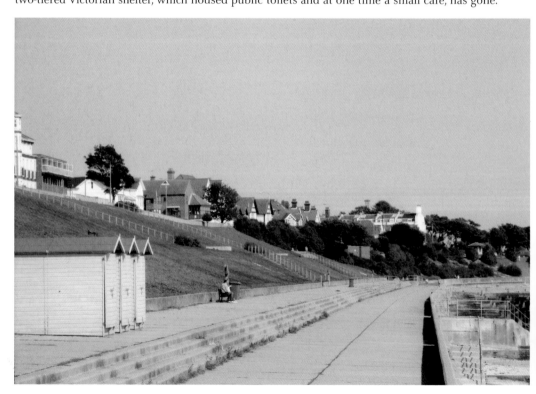

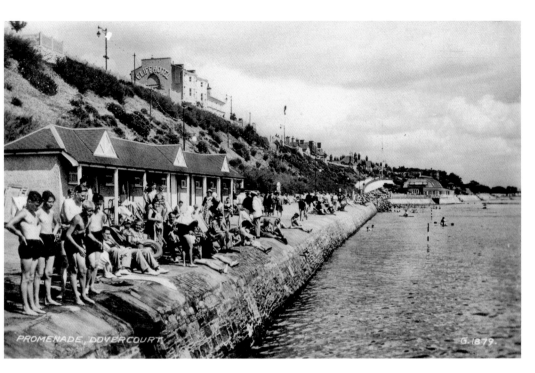

Promenade, Dovercourt, c. 1938
Another photograph from the jetty. The beach huts and the swimmers using them almost fill the narrow promenade at this point. The boys now wear swimming trunks, which not so many years before would have outraged public decency. The beach huts were demolished in April 1969.

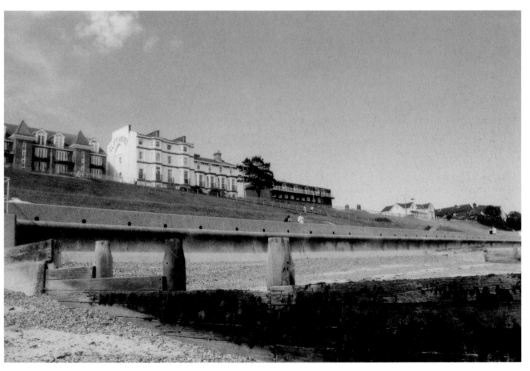

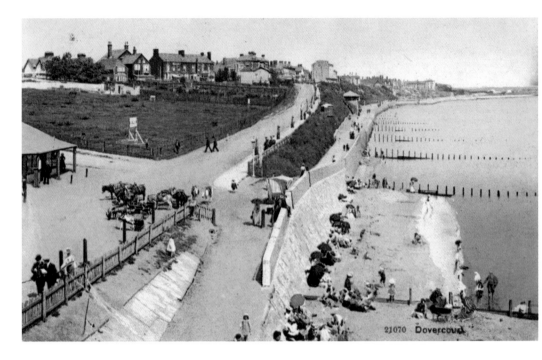

Dovercourt, c. 1904

The cliffs eventually give way near the two lighthouses, and this has always been a popular spot for holidaymakers. The Osborne family ran a donkey rides business here, and the donkeys pulling small carts would take visitors to the foot of the hill for one penny, or to the top for two pennies. Dennant's bazaar can just be seen on the left and boats line the slope. Below, written by Fred on 28 June 1912: 'Having a quiet time here but weather none too warm. Nothing much to do except play with the boy. Imagine me making sand pies!'

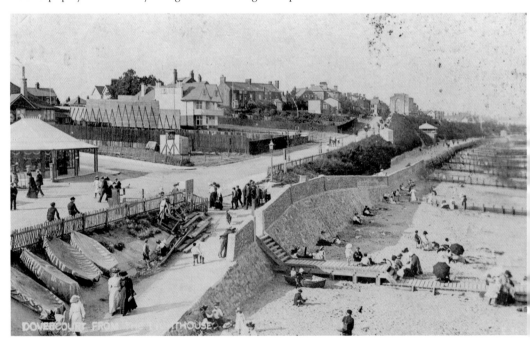

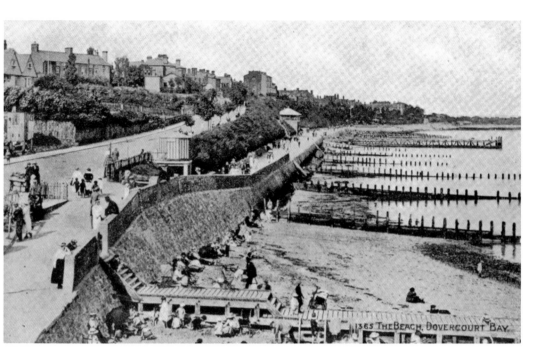

Dovercourt, *c.* 1920

A fascinating view, again from the lighthouse, showing the striped sides of a camera obscura on the edge of the slope. This had been moved from a site further along the promenade. The camera obscura projected an image of the surrounding seafront to those inside watching it in the dark. As could be seen in the previous photograph, the high sea wall has now been opened, and a set of steps lead down to a small wooden jetty.

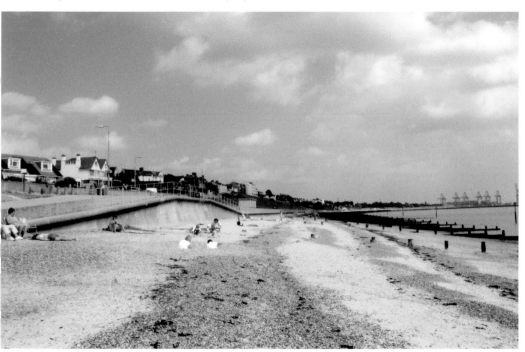

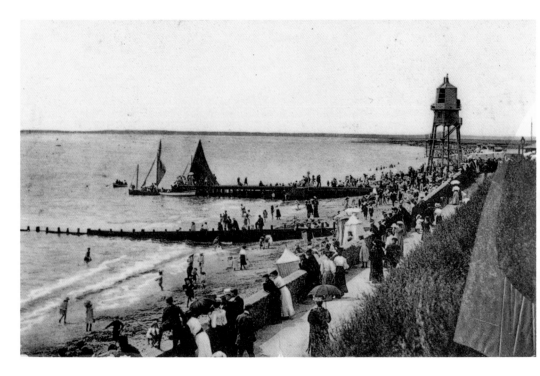

Beach from the Cliffs, Dovercourt, c. 1914

'It's very nice down here in the day time. You would laugh to see me in the water. Wish you were here. We are not allowed on the front at night and all is darkness. Thousands of soldiers. Love Auntie.' A postcard that echoes the thoughts of the words of the Foreign Secretary, Edward Grey: 'the lamps are going out all over Europe, we shall not see them lit again in our lifetime.'

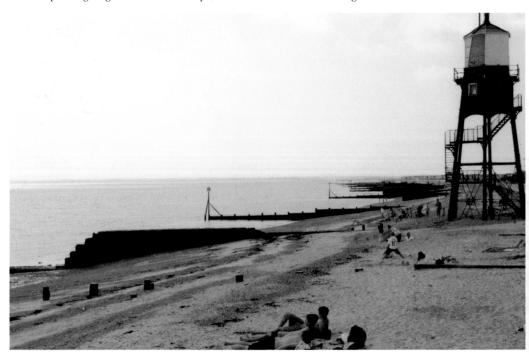

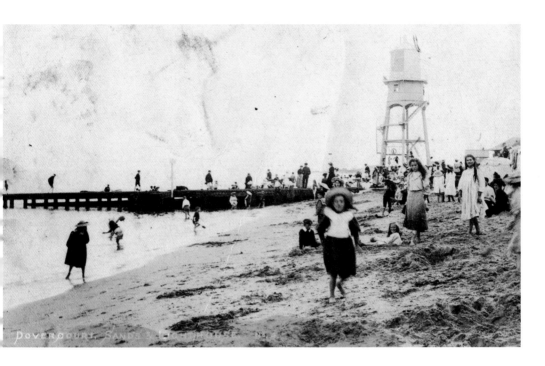

Dovercourt, c. 1909

'Dear Mother, We have arrived here safely. We are having fine weather. Try to find Connie in this picture. Love to all from Winnie.' Sent to Forest Gate on 3 August 1909. Photographers would put photographs in their kiosk windows and holidaymakers would buy them to send home or keep as a precious souvenir before the age when everyone had a camera of some sort. For the photographers it was a living – for us, an invaluable source of social history. In 1911, the Sea Wall and Beach Committee wanted to prohibit photographers employing anyone to tout for business.

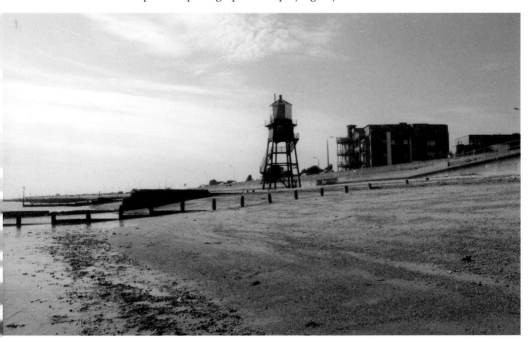

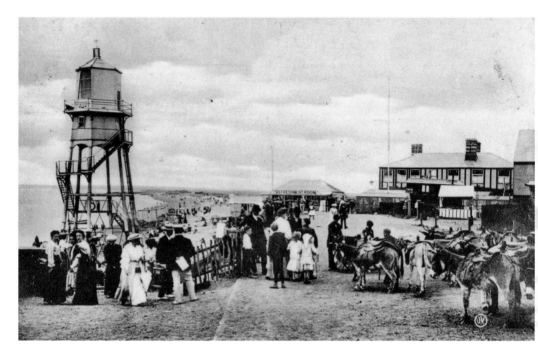

Beach and Lighthouse, Dovercourt Bay, *c.* 1910
A wonderful photograph full of interest, the Osborne's donkey stand is in the right foreground, while the building in the background behind them is the old Phoenix Hotel. The Phoenix, built mostly of wood, was destroyed in a disastrous fire in the early hours of 28 May 1914. A new hotel arose from the ashes (seen on pages 79 and 80), but that too has since gone and been replaced by the Phoenix apartments.

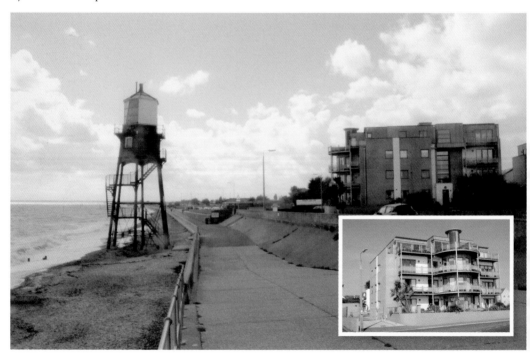

Lighthouse on Lower Parade, Dovercourt, c. 1930

Two of the most iconic features of the Dovercourt seafront are the High and Low Lighthouses. They came into service in November 1863 as successors to the Harwich High and Low Lighthouses. They were in use until 1917 when they were replaced by buoys to mark the safe channel into port. In 1985–88, thanks to the appeal by the High Steward, Cllr Bill Bleakley, which received generous support from the public, they were restored.

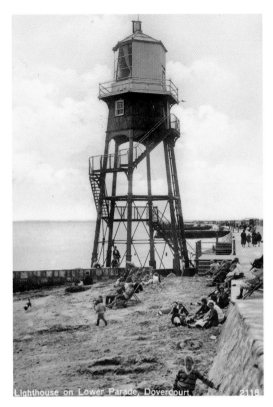

Lighthouse on Lower Parade, Dovercourt 2118

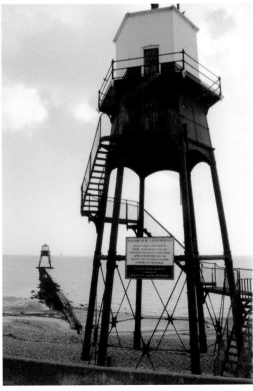

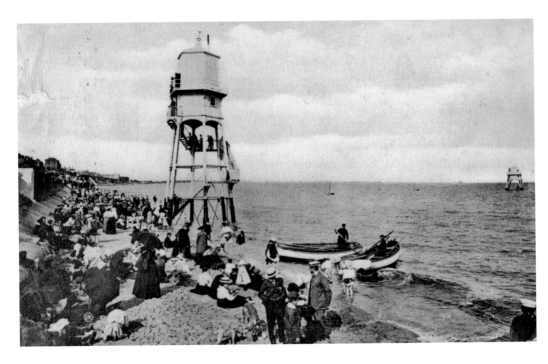

The Lighthouse, Dovercourt Bay, c. 1907

Two years after the new lighthouses came into operation in 1865, thirteen-year-old Maud Homer went on holiday to Dovercourt with her mother and Mary Malster. They travelled by train but had some difficulty in finding accommodation. For ten shillings a week, they could have lodged in an 'odiferous' cottage with Mrs Inward and her nine children. As they couldn't afford the Cliff Hotel, they stayed at 18 Victoria Terrace for one pound a week.

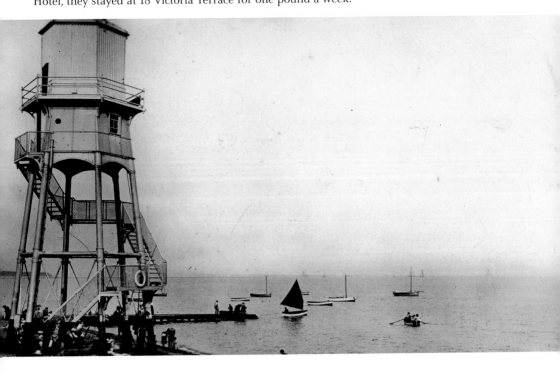

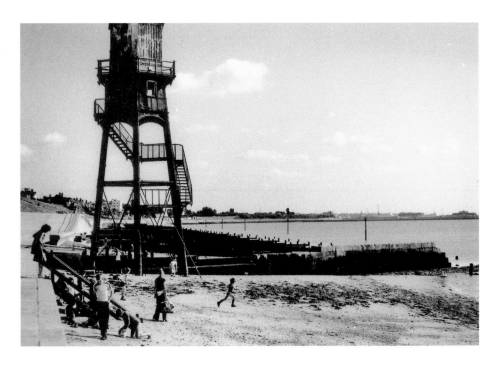

High Lighthouse, c. 1980

Maud kept a journal of her holiday. On Friday 1 September: 'Down at 7.40. After breakfast we went to the beach and after paying five shillings for one dozen bathing tickets we secured a machine which was let down into the water and Mary (who was much better with no headache) and I had a regular good bathe, I was in 2 minutes. Mary tried to swim and float much to all our amusement.'

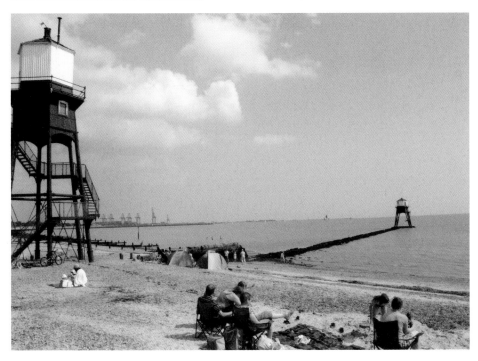

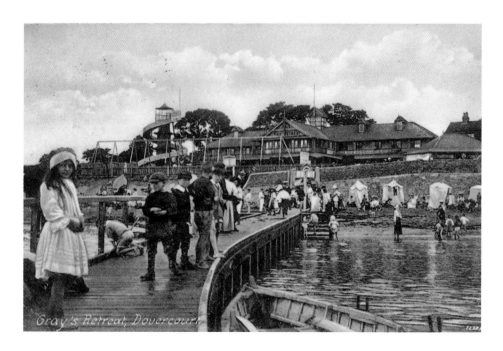

Gray's Retreat, Dovercourt, c. 1914

To the south, the promenade was not built up and much of the land was low-lying marshes. Maud found the smell from them 'very disagreeable' but everyone was sociable: '...the bathers speak, and smile to each other and warn one of the jelly fishes that Mary finds sting horribly.' This view from the jetty shows bathing tents and Gray's Retreat in the background. There is little evidence of any special clothing for the beach. The Retreat was a vast wooden building dating from 1889.

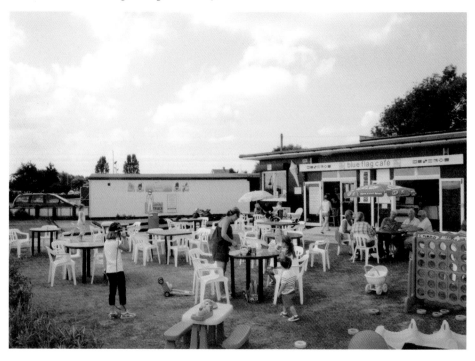

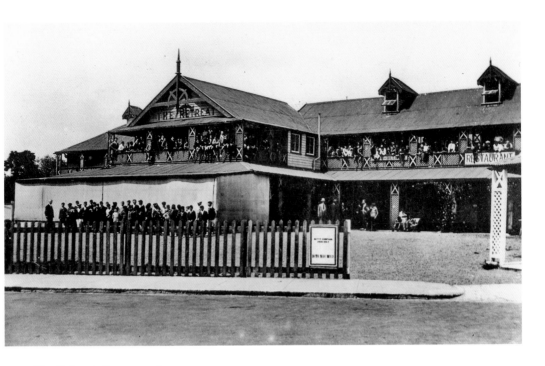

The Retreat, Dovercourt

The Retreat, which was a temperance establishment, could accommodate 2,000 people and had a restaurant and dance hall, as well as the nearby helter-skelter. It was popular with parties of children from London County Council schools, where they slept in long dormitories. It is possible to see a great many children in this photograph. During both the First and Second World Wars, the building provided billets for troops. It was eventually demolished sometime in the 1950s. An apartment building, echoing some features of the Retreat, is now under construction.

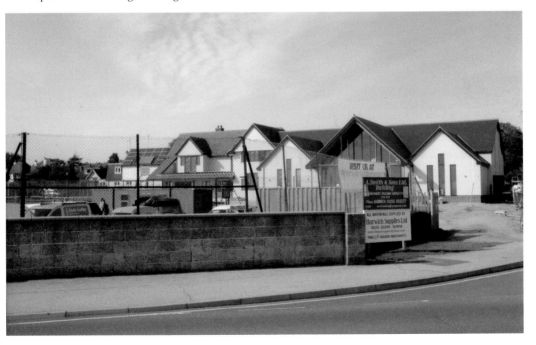

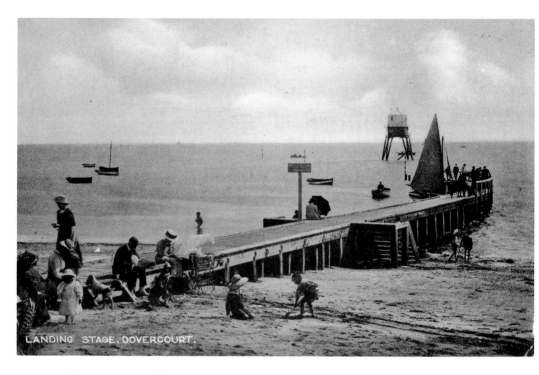

Landing Stage, Dovercourt, *c.* 1910

Holidaymakers queue for boat trips. Maud Homer, Mary and her mother took a boat trip while on holiday, though not from here. 'Had a delicious bathe, tide coming in, afterwards went through the spa to the breakwater where we took a boat for an hour. The boatman was a very chatty fellow and spoke of the cattle plague and price of milk very sensibly.'

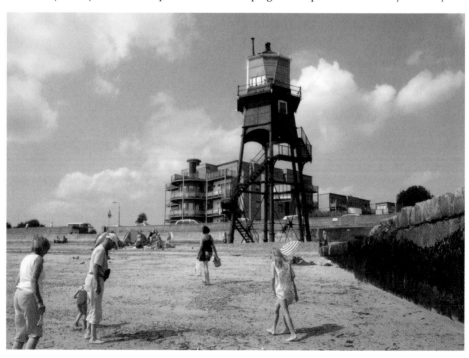

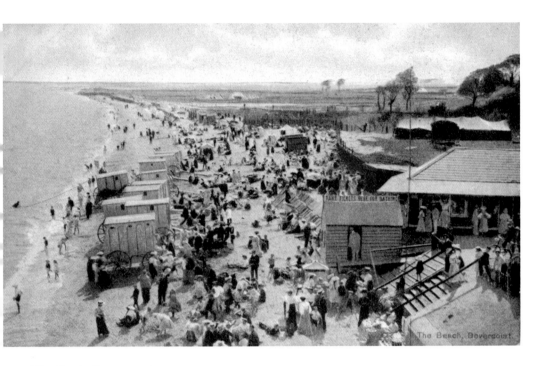

The Sands, Dovercourt, c. 1905

The stretch of coast beyond the Phoenix Hotel was owned by the Lord of the Manor, but from around 1900 was leased to the council. Bathing machines stood near the jetty and were owned by the Phoenix Hotel. Bathing was a contentious issue in late Victorian times. Around the time of this photograph, mixed bathing was allowed at Dovercourt. When Maud Homer visited in 1865, she would have been lowered into the water from one of these machines, for which she had bought tickets.

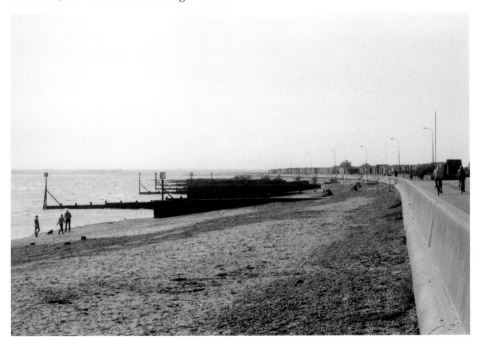

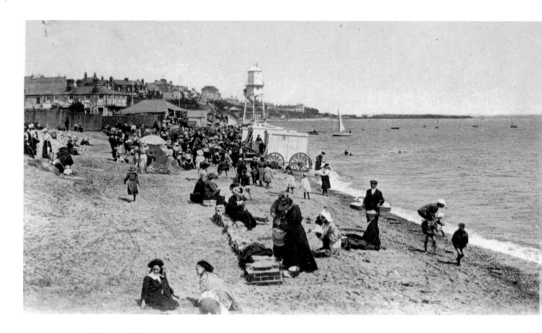

Dovercourt, The Sands, c. 1905

Costumes were only worn for bathing, and many visitors contented themselves with paddling in their ordinary clothes. No one undressed to sit on the sands. The men wore collar and tie and a hat. In 1902, the council adopted by-laws for Public Bathing and Bathing Machines: 'No-one over the 10 years of age shall bathe on the beach between the hours of 8 a.m. and 9 p.m., unless clothed with sufficient dress or covering extending from the neck to the knee, and then from a hut or tent placed on the beach.' And that meant paying to use a machine or tent.

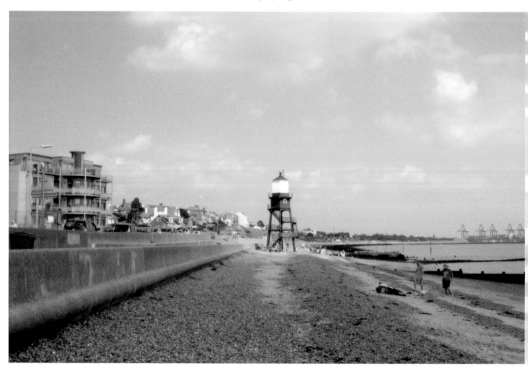

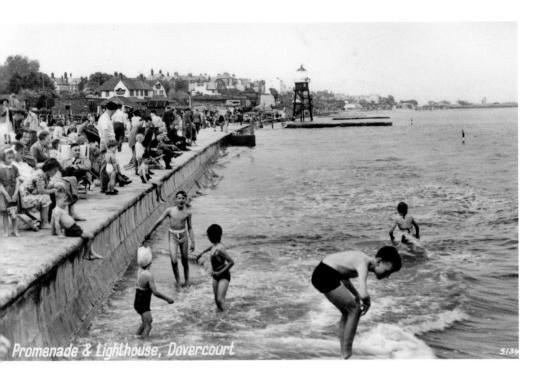

Promenade & Lighthouse, Dovercourt

Promenade and Lighthouse, *c.* 1952
After two world wars in less than fifty years, it is a totally different picture. The new Phoenix Hotel can be seen in the distance on the left. Later, in the 1950s, Dick sent Ted a 'picture of the glorious East Coast to cheer you up! It is wonderfully hot today and I regret that I shall be working next week.' Both photographs show that the old jetty that was so popular has gone, probably removed for fear of invasion during the Second World War.

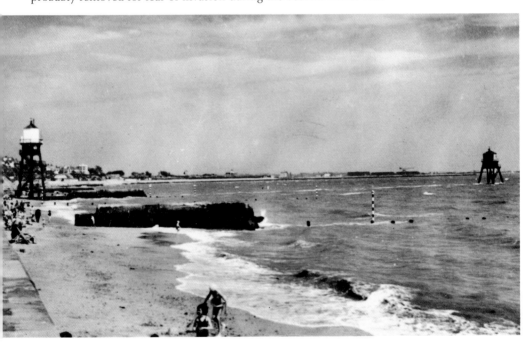

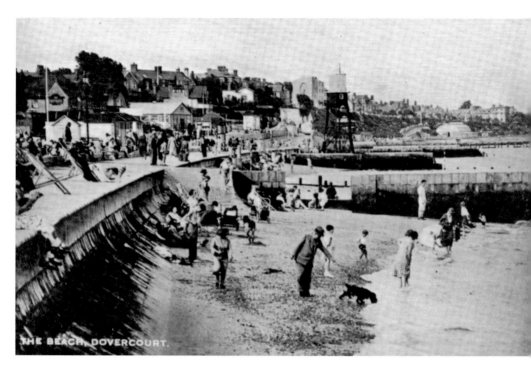

The Beach, Dovercourt, c. 1936
The gently shelving clean beach has always been the main attraction of Dovercourt, but this part of the resort has always been a lively hub for other activities.

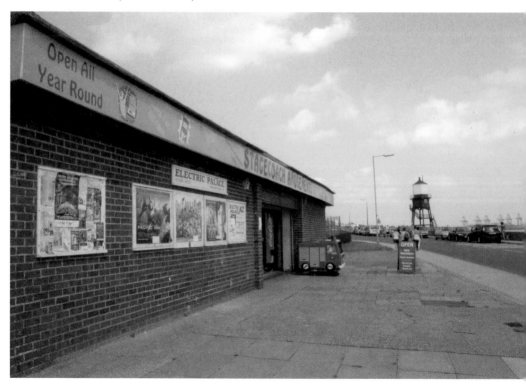

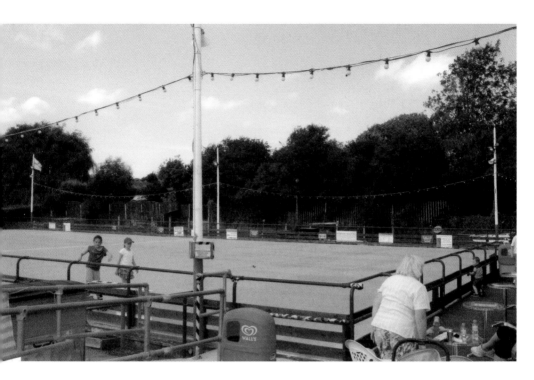

Roller Skating, 2013
Today there is an amusement arcade, roller skating rink, tennis courts and – my favourite when at the seaside – putting greens.

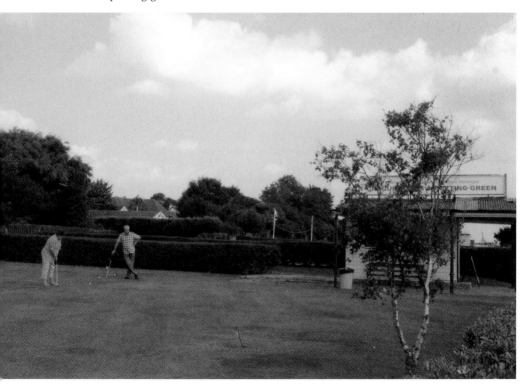

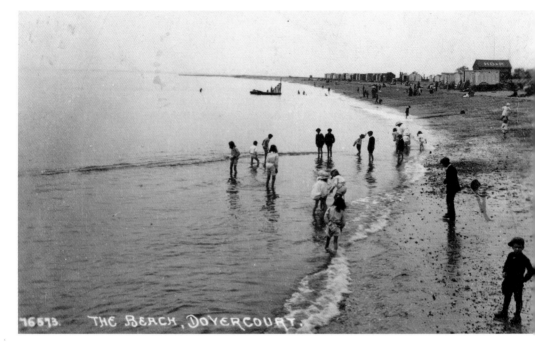

The Beach, Dovercourt, c. 1920

'Just a card as I promised from Dovercourt. The beach is all sand, just lovely for paddling and bathing.' Sent to Hornsey, London. Although there is a row of huts, the promenade has not been extended at this time and effectively ended at the Phoenix Hotel. The owner of the Phoenix Hotel put up the row of huts to replace the bathing machines, which had become obsolete just before the First World War.

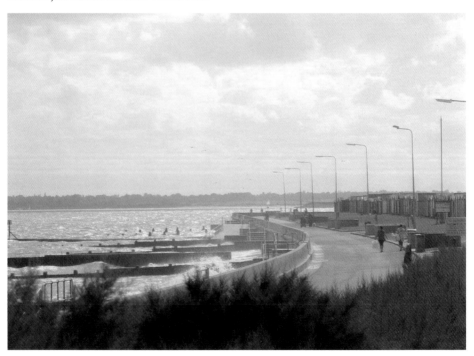

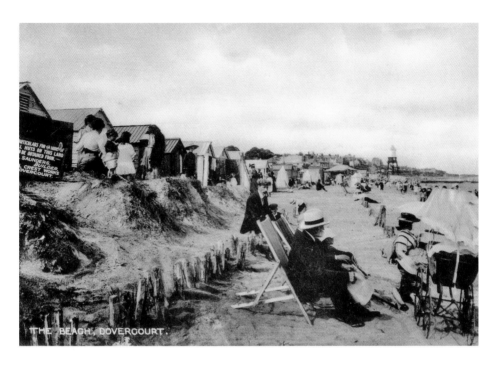

The Beach, Dovercourt, *c.* 1906

The site announces that 'Particulars for the hire of all huts on this land can be obtained from E. Saunders Builder, Hill Crest Works, Dovercourt.' Some bathing tents can be seen in the distance. There was pressure in the local council around this time to allow people to bathe without having to pay for huts in which to change. Within a matter of a few years and an intervening war, nearly all the restrictions would disappear.

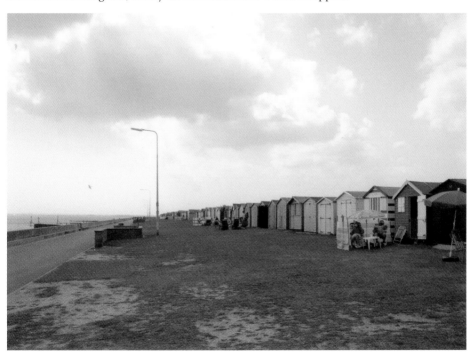

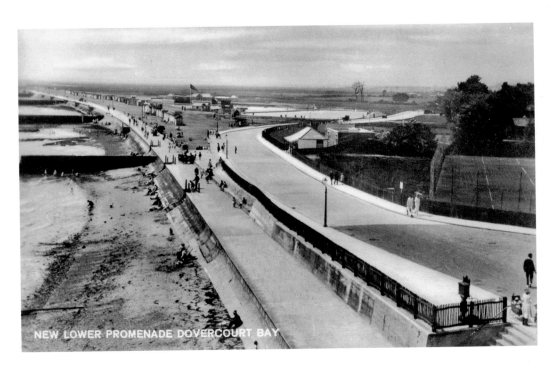

NEW LOWER PROMENADE DOVERCOURT BAY

New Lower Promenade, c. 1925

The period after the end of the First World War saw high levels of unemployment in the early 1920s, so the government introduced grants for local councils to encourage development projects that would create jobs. The council at Harwich took full advantage of the scheme and set about both improving the sea defences at this lower part of Dovercourt and creating new attractions. This extension to the promenade and the new road really opened up this lower lying area of the town.

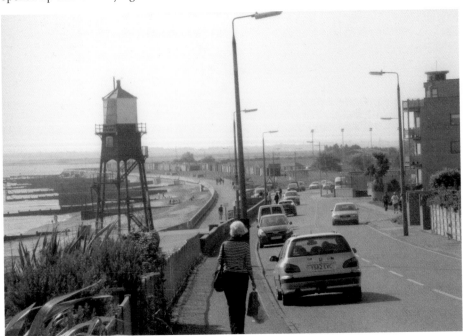

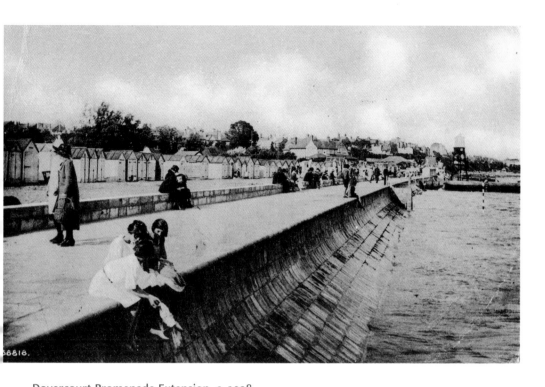

Dovercourt Promenade Extension, *c.* 1928
One effect of the new promenade was to allow the beach huts to spread further along the front. More of the lovely beach was made accessible and, as can be seen, the new work became very popular. A 1929 guidebook compiled by the London and North Eastern Railway (LNER) promotes Dovercourt for a 'Restful Holiday and Plenty of Sunshine'.

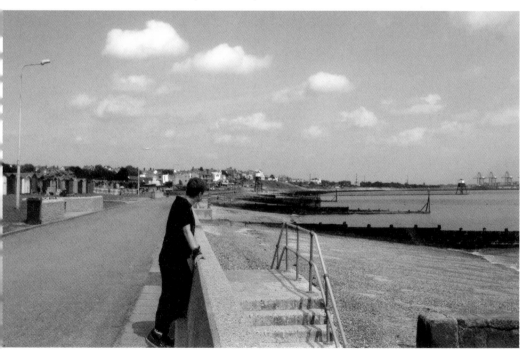

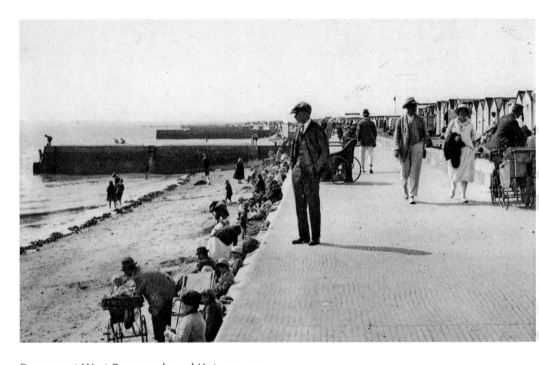

Dovercourt West Promenade and Huts, *c.* 1930

Beach hut heaven, at the back of a broad promenade looking out to sea; it was a very short walk to sit on the sand or go for a paddle or swim. From this open promenade, it is possible to look across and see the Naze Tower at Walton, and there is a long beach hut-lined walk before West End Lane and, beyond that, low-lying land and marshes.

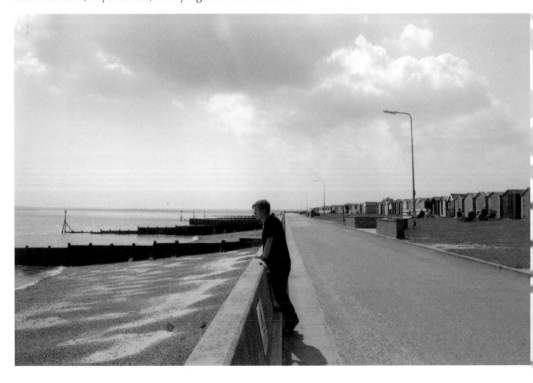

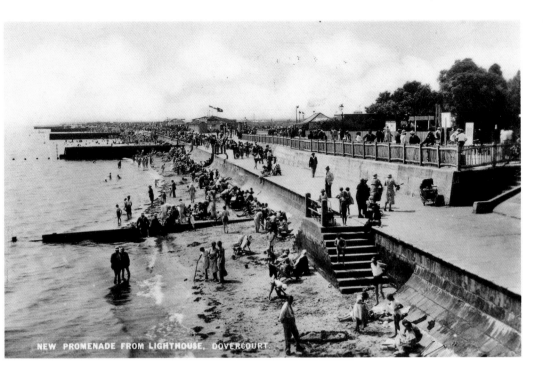

New Promenade from Lighthouse, *c.* 1930
The liveliness of this scene is not solely due to the new promenade, but other works that were carried out nearby through the government scheme.

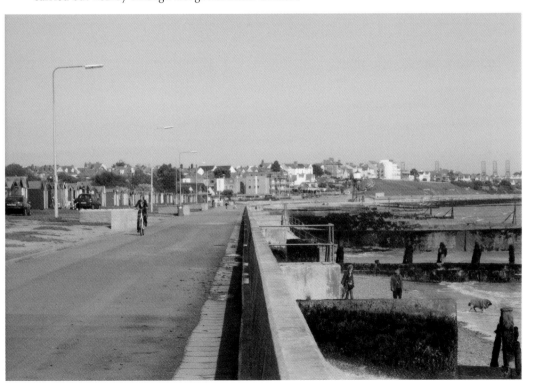

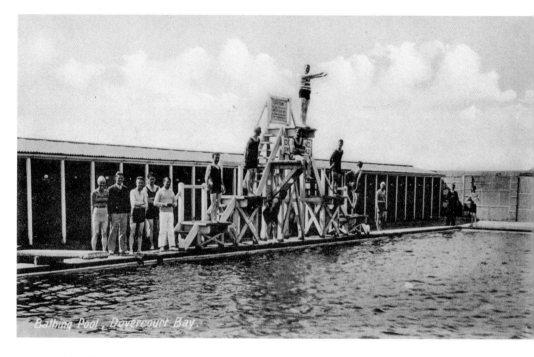

Bathing Pool, Dovercourt Bay, *c*. 1925

In 1924, the resort got a new swimming pool to provide 'safe bathing'. The pool was 210 feet long and 75 feet wide. There were changing cubicles at each end, one end for ladies and one for the gentlemen. The diving pool seen here was at the end of the gentlemen's cubicles. The town guide for 1937 describes it as 'the finest sea-water bathing pool in East Anglia ... by means of ingenious pumps the water is changed completely every twenty four hours'. In 1979, Tendring District Council took the decision to cover and heat the pool.

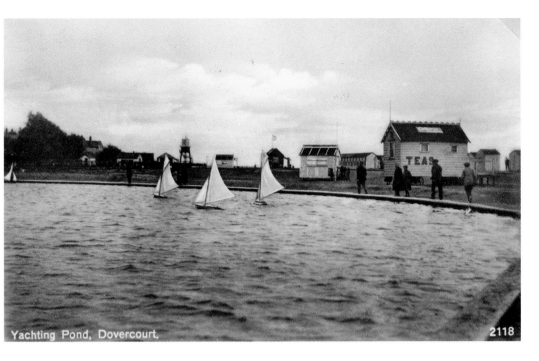

Yachting Pond, Dovercourt. 2118

Yachting Pond, c. 1929

Like the swimming pool built under the government scheme, a large model yacht pond was built nearby. This was for the free use of the public. There was a Model Yacht Club that met for racing on the Wednesday evenings and Sunday afternoons. Written in October 1929 to South Woodford: 'We are having a lovely time. The weather quite nice for the time of the year.' The waters were decidedly choppy when I was there in early September, but one brave yachtsman was there.

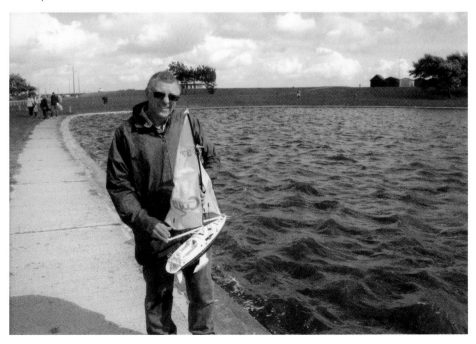

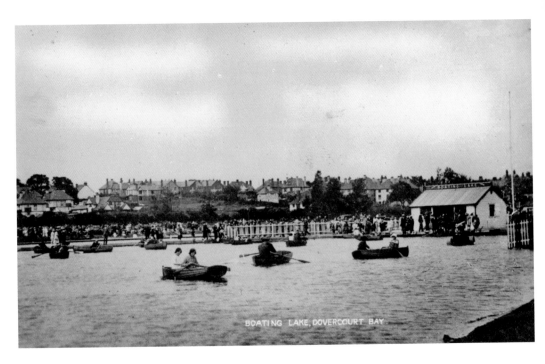

Boating Lake, Dovercourt Bay, *c.* 1926

Mr Cann had the lease on the boating lake and charged six pence per person for each half hour. There is a larger crowd watching the model boats than the rowers. Sadly, there were no boats out on my three visits. Writing to Lower Edmonton, London, the holidaymakers were having 'lovely weather ... very nice place, very nice people. We are getting very lazy. The sea at present is like a pond.'

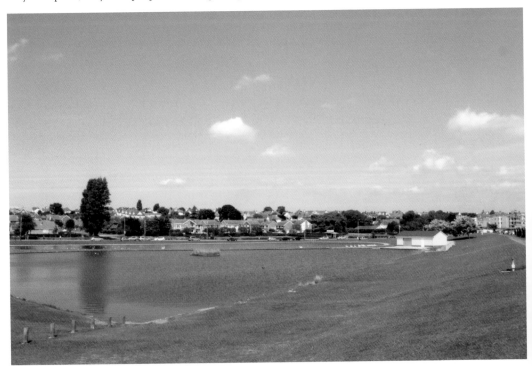

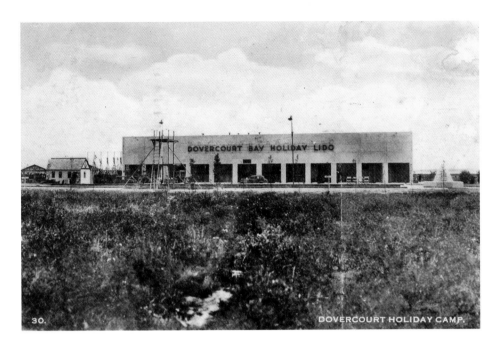

Dovercourt Bay Holiday Camp, *c.* **1948**

In 1937, the town guide announced a new attraction. 'Dovercourt Bay Holiday Camp. This new holiday camp is situated on the seafront in its own grounds of 40 acres. Built under the supervision of the Corporation of Harwich, and equipped with company's running water and sanitation ... and constructed in concrete and steel.' The council bought 76 acres in total and laid out the playing fields, which can still be seen in front of the camp. The camp was opened as the Dovercourt Bay Holiday Lido. LNER featured it on one of their classic rail posters.

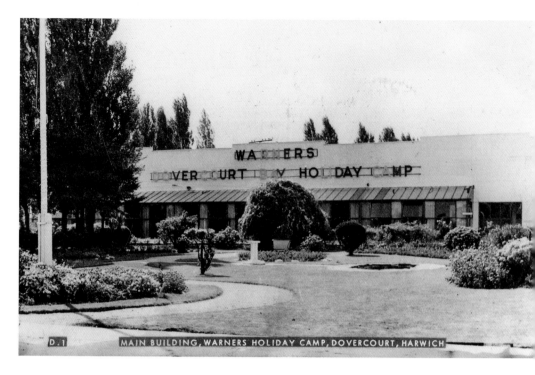

D.1 MAIN BUILDING, WARNERS HOLIDAY CAMP, DOVERCOURT, HARWICH

Dovercourt Holiday Camp

Captain Harry Warner was one of the holiday camp pioneers with his friend Billy Butlin. He opened his first camp at Northney, Hayling Island, in 1932, and had four camps open at the outbreak of the Second World War. The town guide for 1937 proudly boasted that the new camp 'is without doubt the best equipped and most luxurious on the S. E. Coast'.

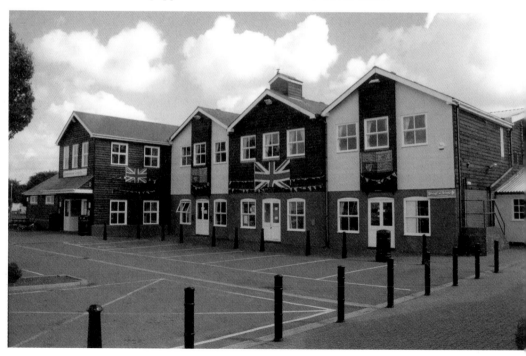

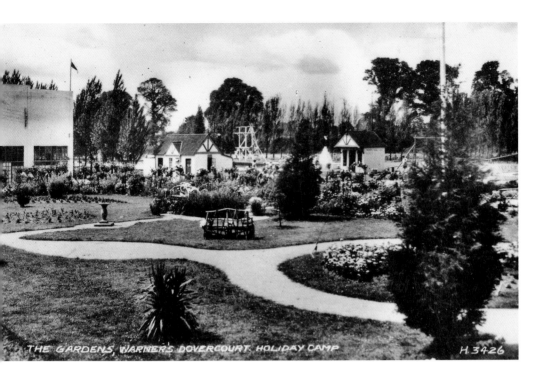

The Gardens Warner's Dovercourt Holiday Camp

At the end of the 1938 season, the camp was taken over by the Refugee Children's Movement. Kindertransport children fleeing from persecution in Europe and arriving at Harwich from the Hook of Holland were temporarily housed here until March 1939. During the Second World War, it was requisitioned for military use and in 1942 became a prisoner of war camp.

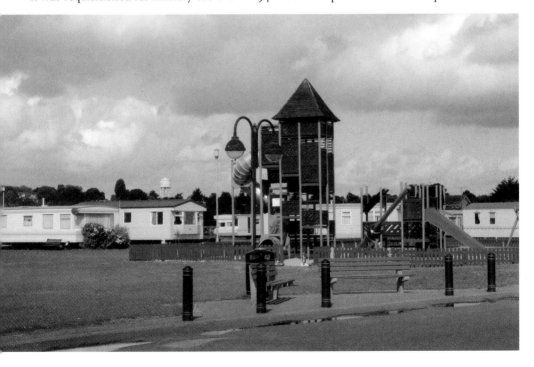

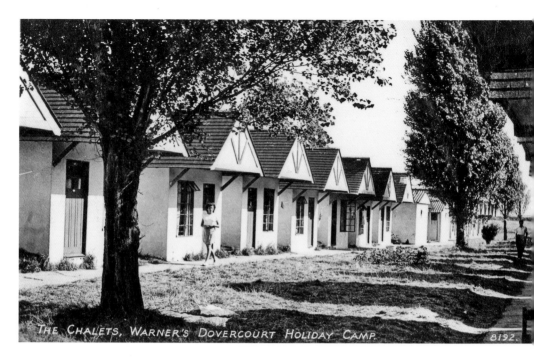

The Chalets, Warner's Dovercourt Holiday Camp, c. 1950
'Every chalet with its own water supply and electric light', as the guidebook said. As the Warner's Camp was demolished over twenty years ago, today's photographs are of the Dovercourt Caravan Park, situated a short distance from the old holiday camp. Dovercourt Caravan Park has been in the resort for over sixty years. Here there are luxury caravans, a heated swimming pool, play areas, bars, diners and every sort of facility for the holidaymaker or caravan owner.

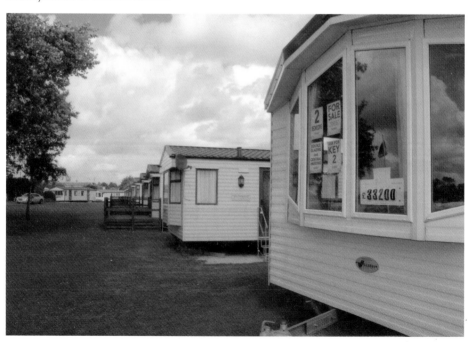

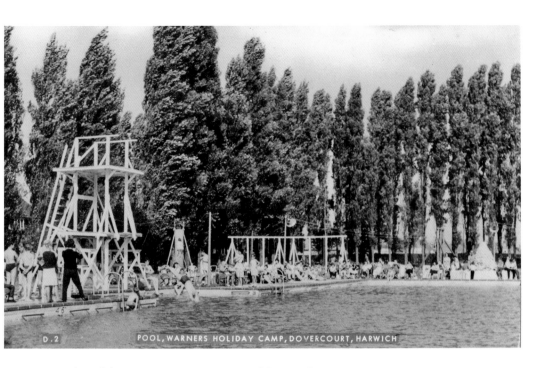

POOL, WARNERS HOLIDAY CAMP, DOVERCOURT, HARWICH

Warner's Holiday Camp, Dovercourt, Harwich, *c.* 1965

'Dear Nan, Having a good time – good weather so far. Got thrown in the pool and got out alright.' Shades of Ted Bovis, Spike, Peggy and Gladys, for this was the holiday camp that was used as the setting for the popular television comedy series *Hi-De-Hi*. Out of season from 1980–87, it was transformed into Maplins Holiday Camp. Sadly the camp, which could accommodate 1,500 holidaymakers, closed in 1990, losing Dovercourt some 11,000 visitors a year. The buildings were demolished in 1992, and the site is now covered by housing.

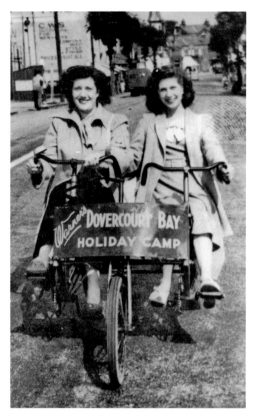

A Tricycle Built for Two, *c.* 1950
Beryl Sherringham and her friend, Eileen Barrs, getting out and about. Once a familiar sight bringing holidaymakers from the camp into Dovercourt, they are now a distant memory, although Dovercourt itself still has something of the 1950s about it. This is a resort where you can enjoy Blue Flag award beaches with some of the cleanest sand you'll ever see, paddle, swim, go on the putting green, play tennis, sail a model boat and roller skate. There is a friendly beachside café and miles of promenade to enjoy a bracing walk, jog or cycle, taking you round into fascinating Harwich. It is a place for holidays as they used to be, although, sadly, fewer people take advantage of such delights.

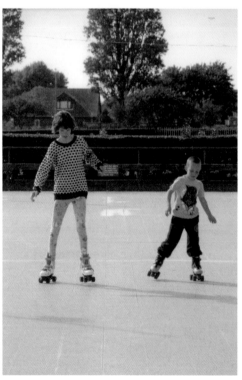